Marty Noble's
sugar skulls

Skyhorse Publishing books may be purchased in bulk at special discounts for sales promotion, corporate gifts, fund-raising, or educational purposes. Special editions can also be created to specifications. For details, contact the Special Sales Department, Skyhorse Publishing, 307 West 36th Street, 11th Floor, New York, NY 10018 or info@skyhorsepublishing.com.

Skyhorse® and Skyhorse Publishing® are registered trademarks of Skyhorse Publishing, Inc.®, a Delaware corporation.

Visit our website at www.skyhorsepublishing.com.

10 9 8 7 6

Library of Congress Cataloging-in-Publication Data is available on file.

Cover design by Brian Peterson
Cover illustration by Marty Noble

ISBN: 978-1-5107-1035-1

Printed in China

Marty Noble's sugar skulls

New York Times Bestselling Artists' Adult Coloring Books

MARTY NOBLE

Skyhorse Publishing

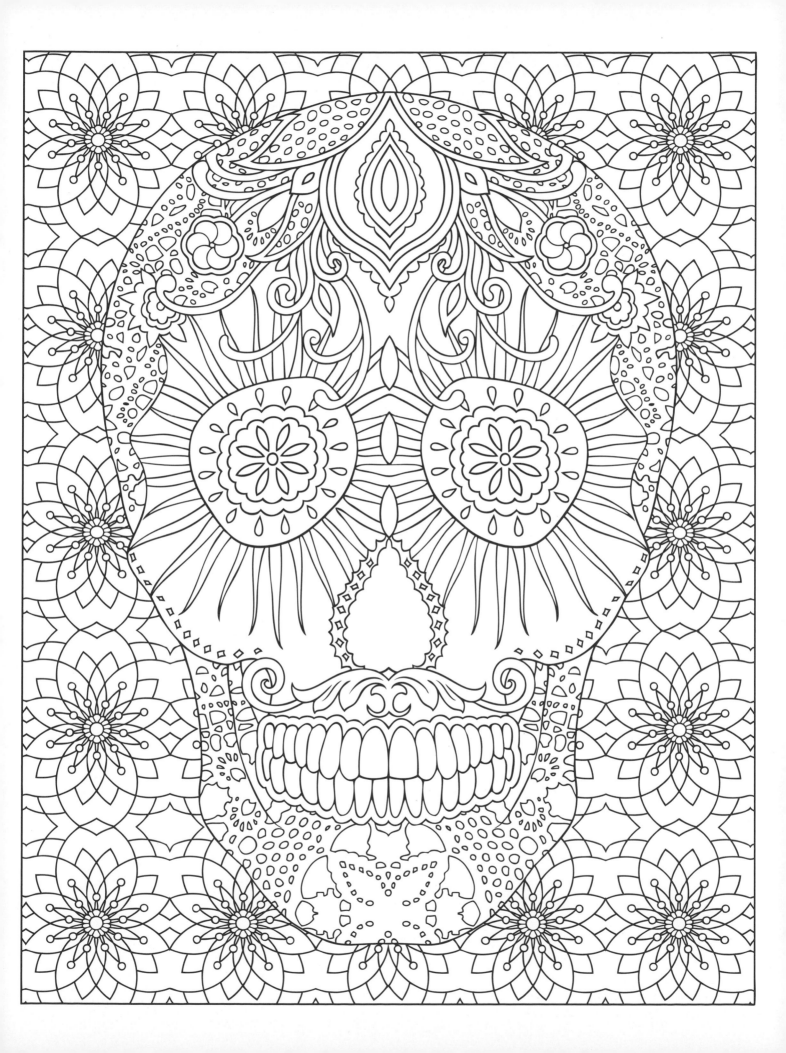

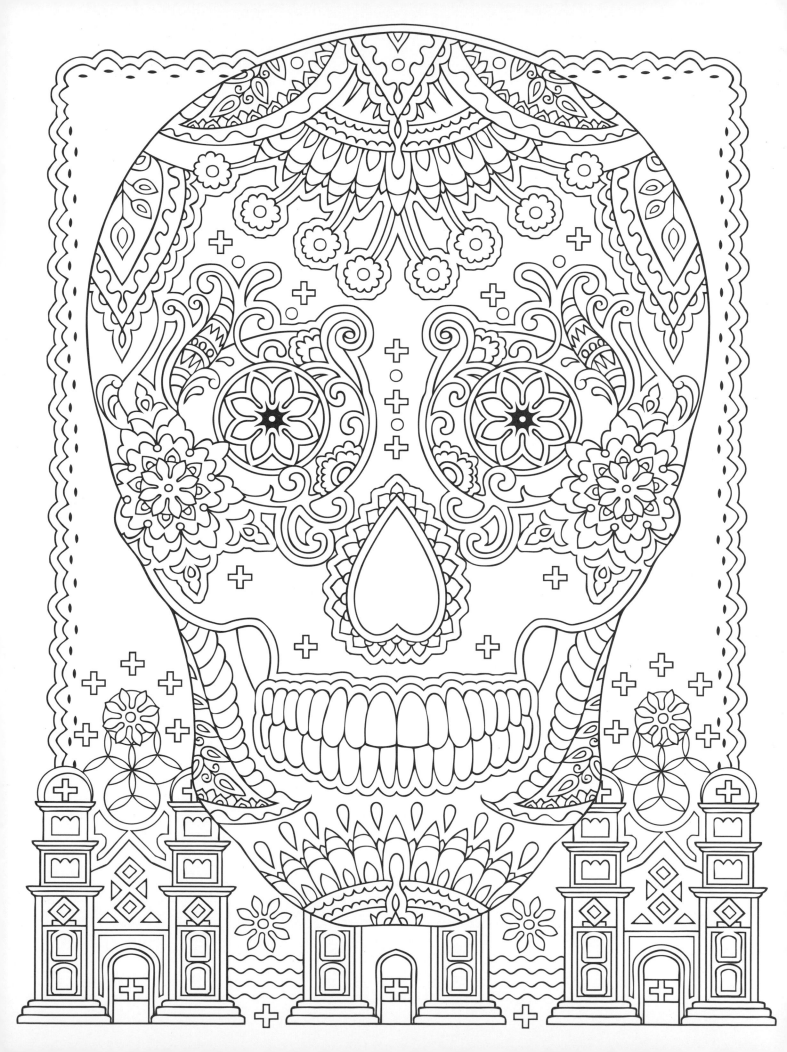

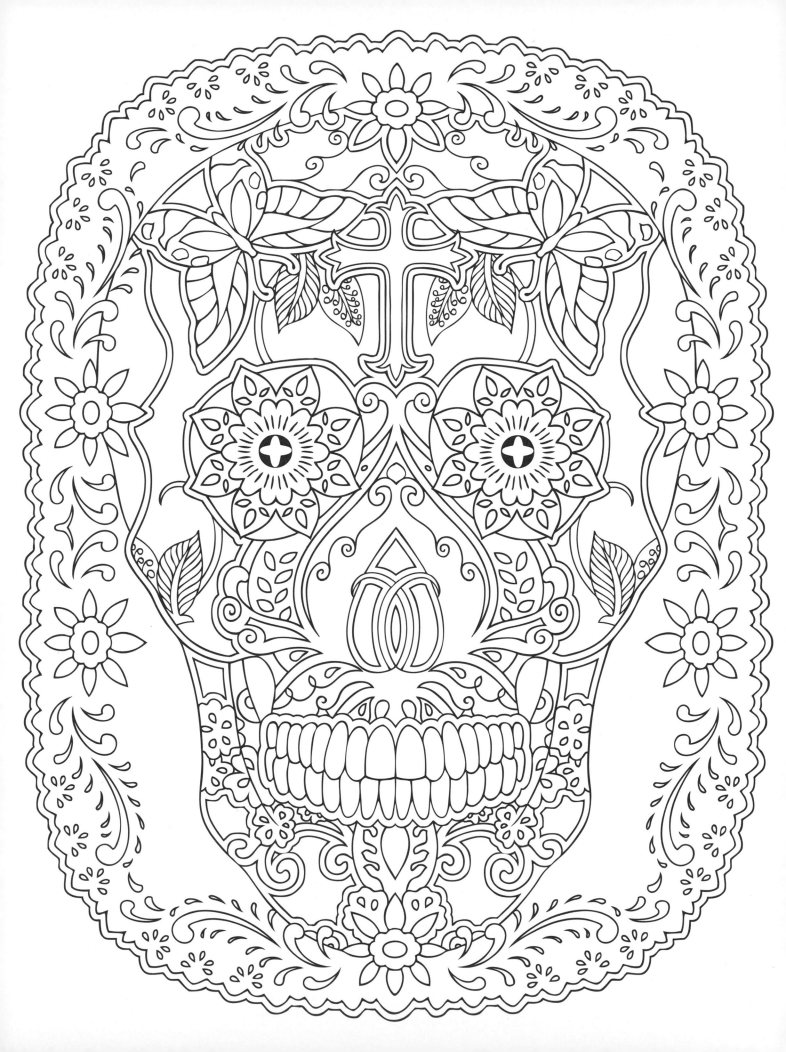

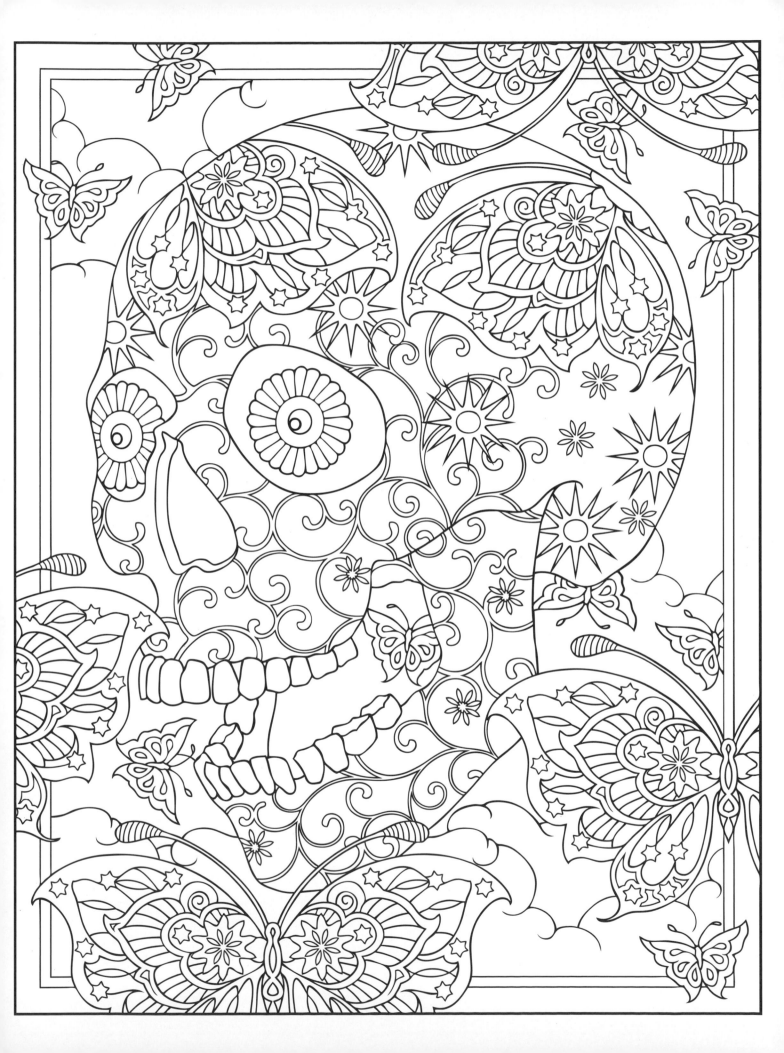

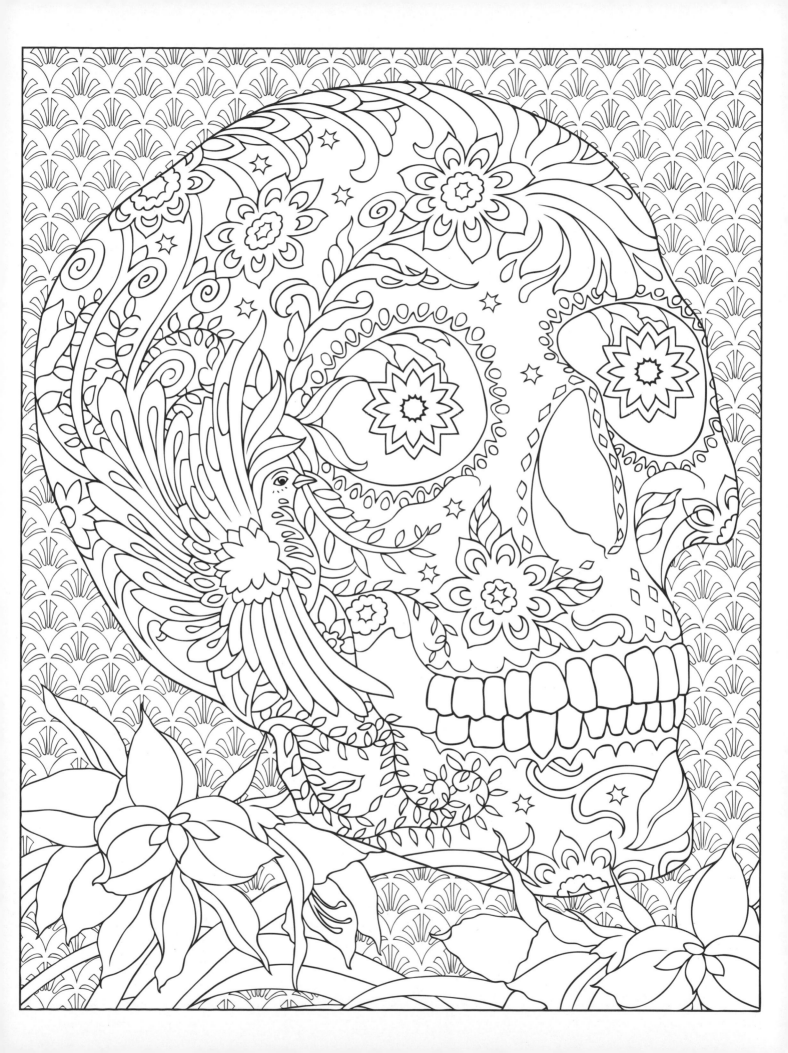

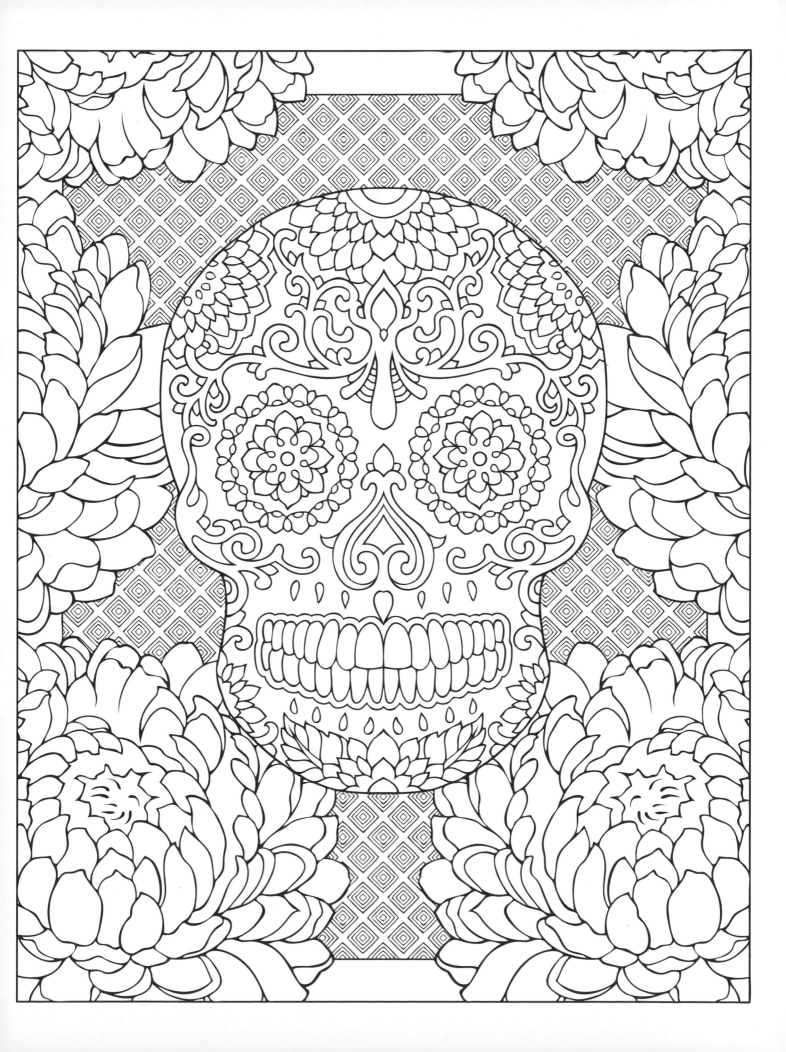

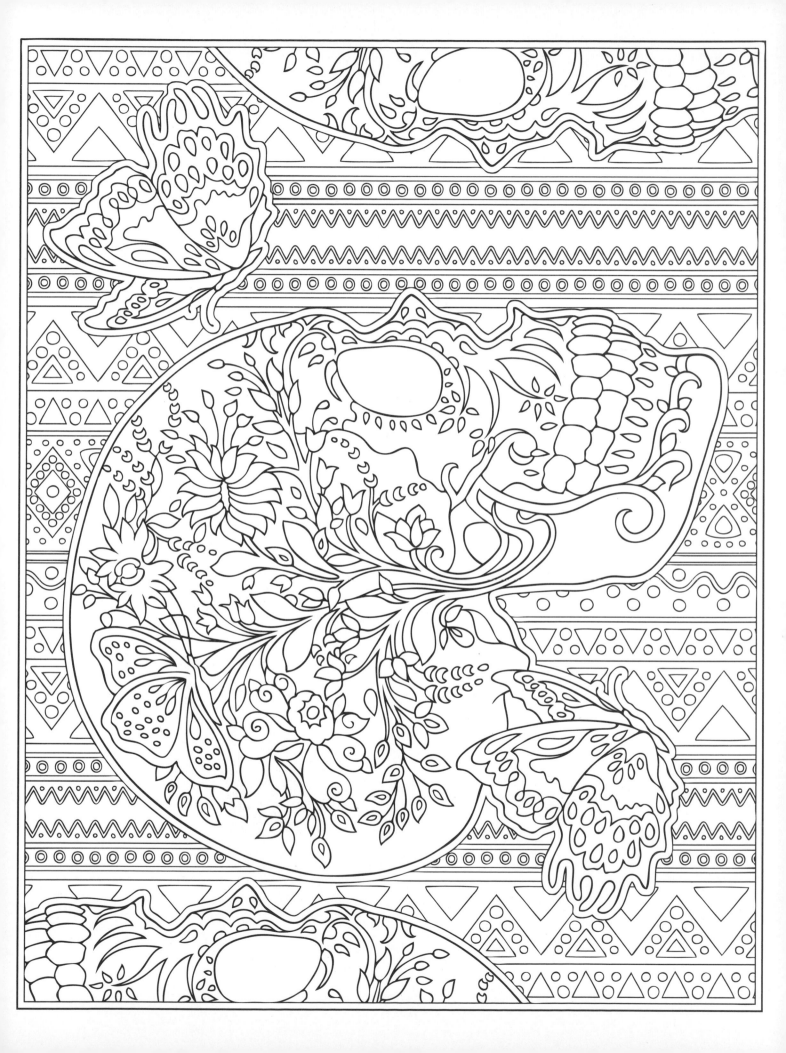

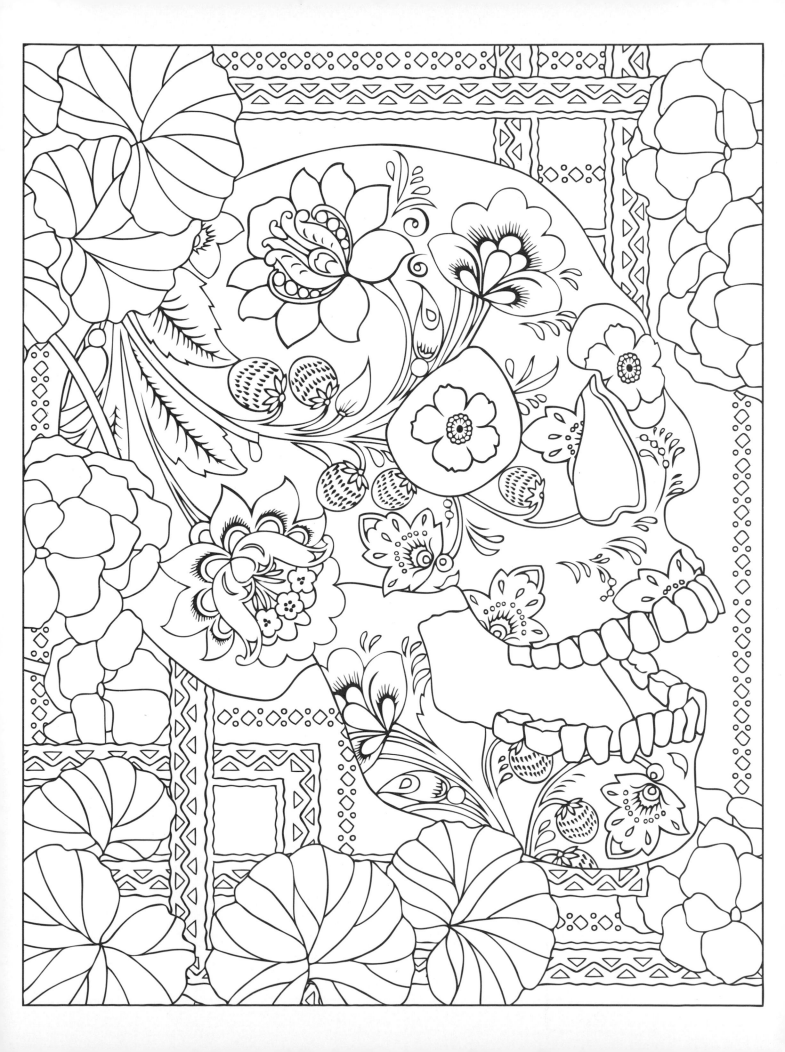

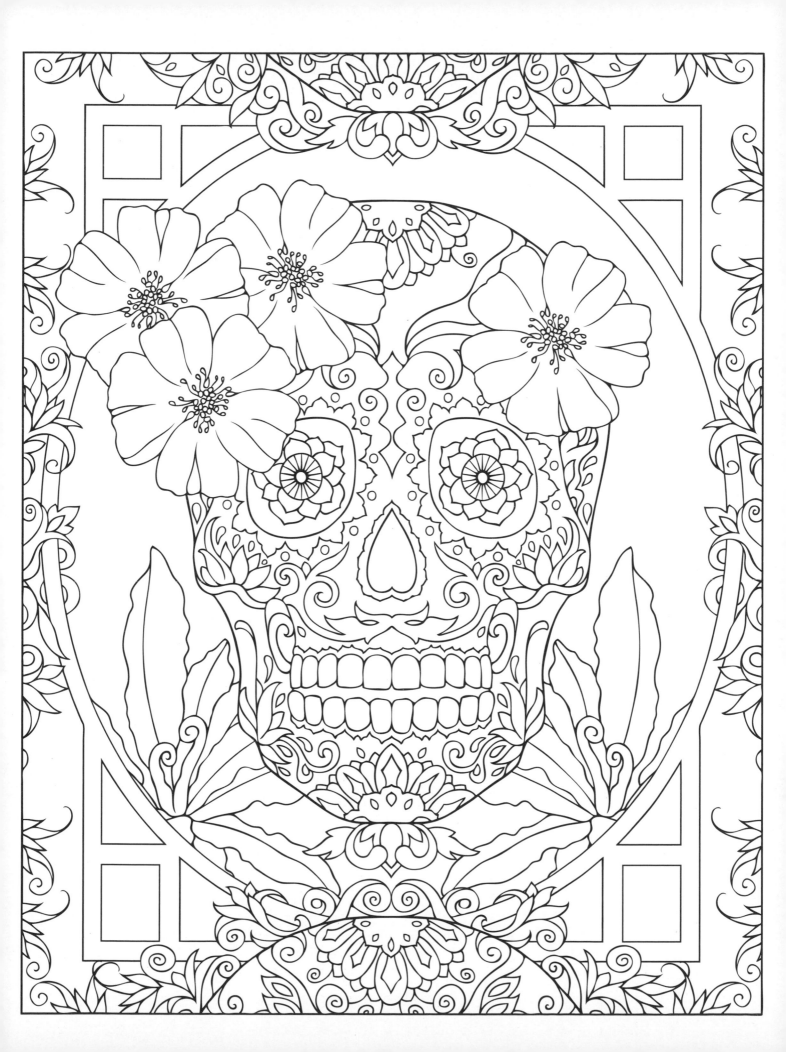

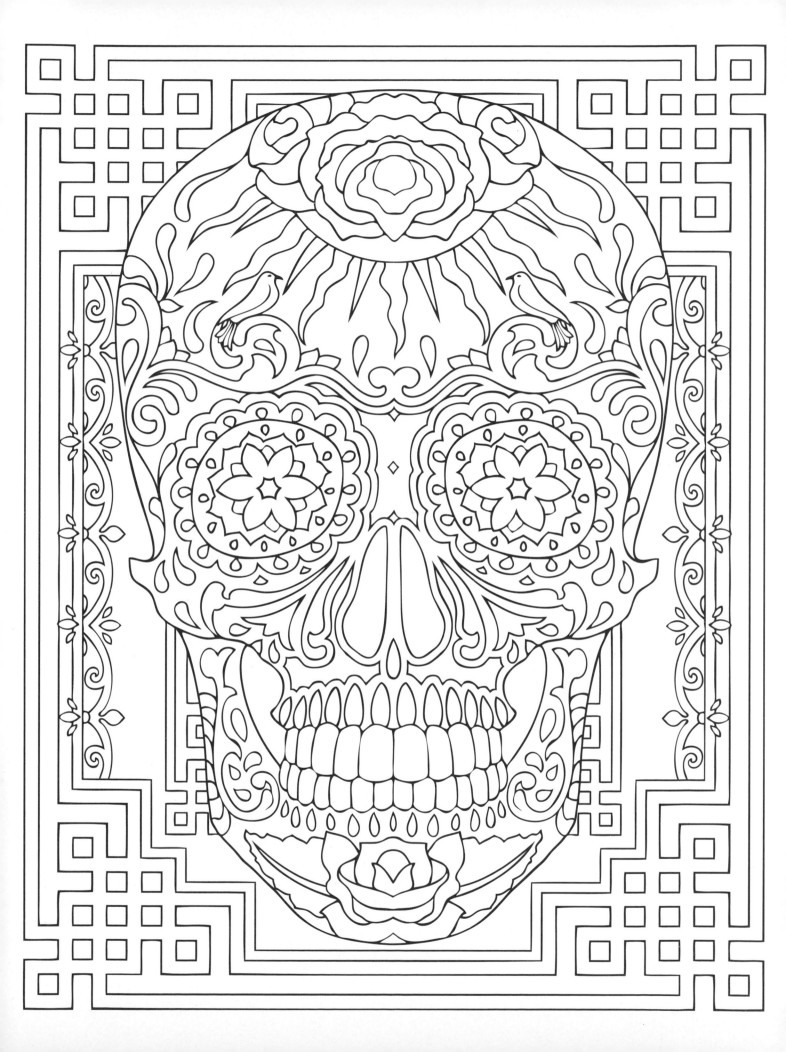

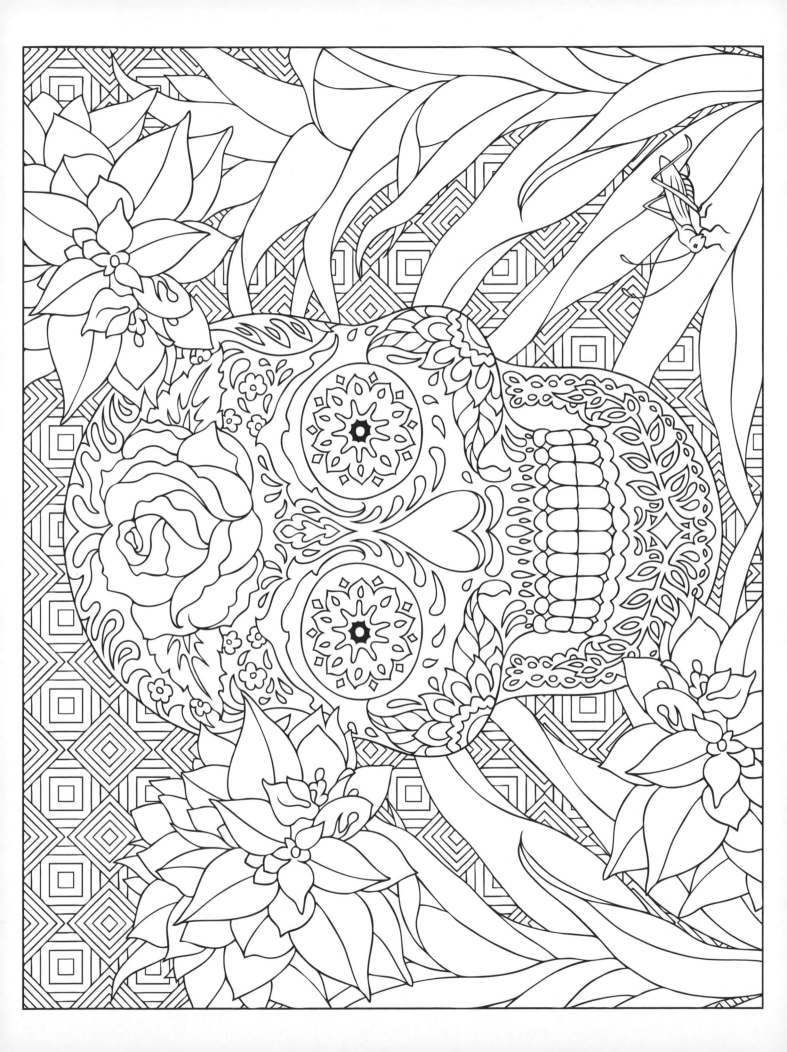

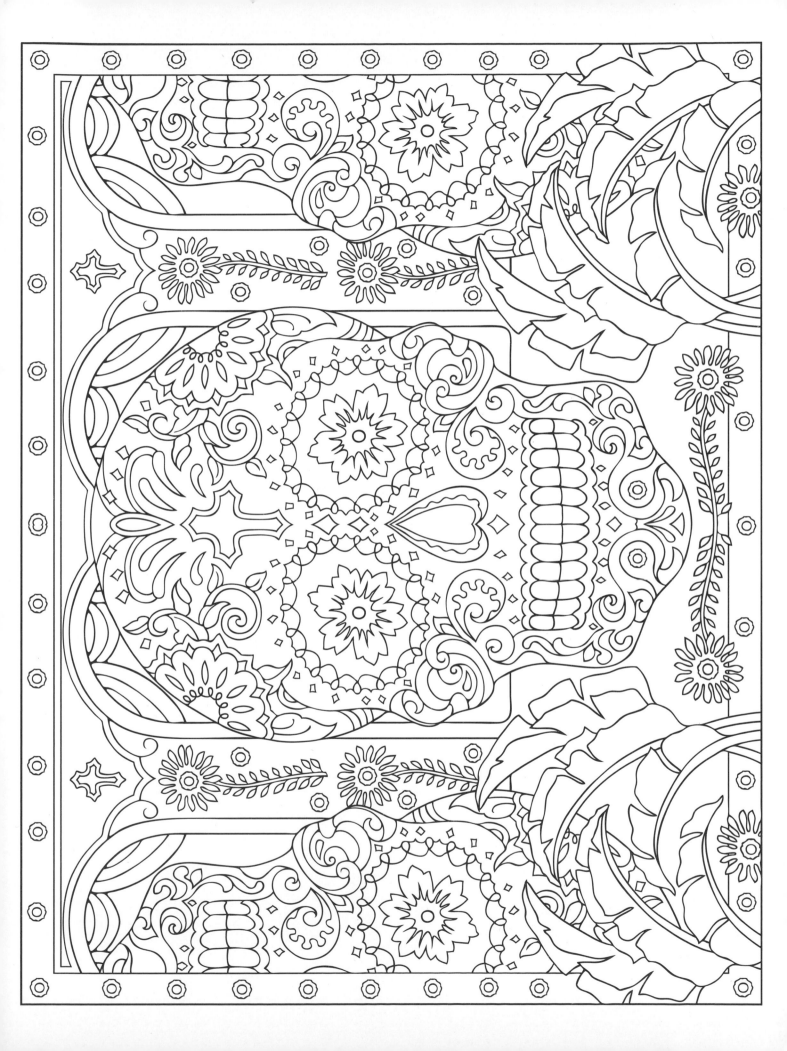

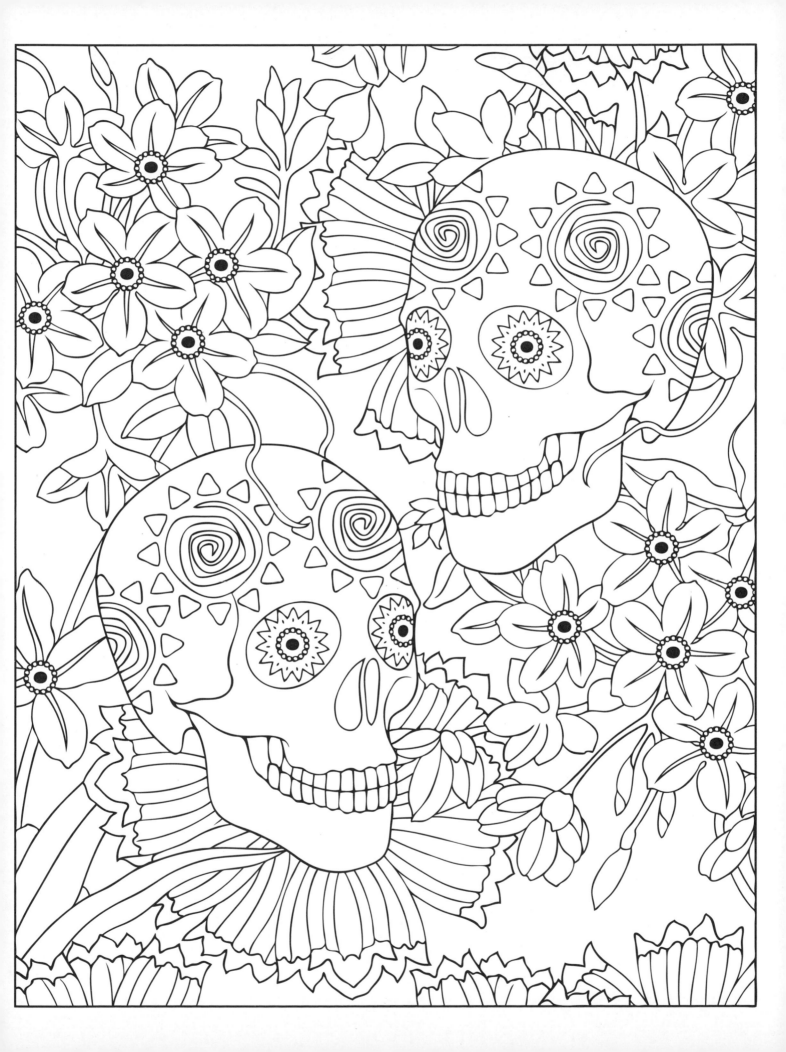

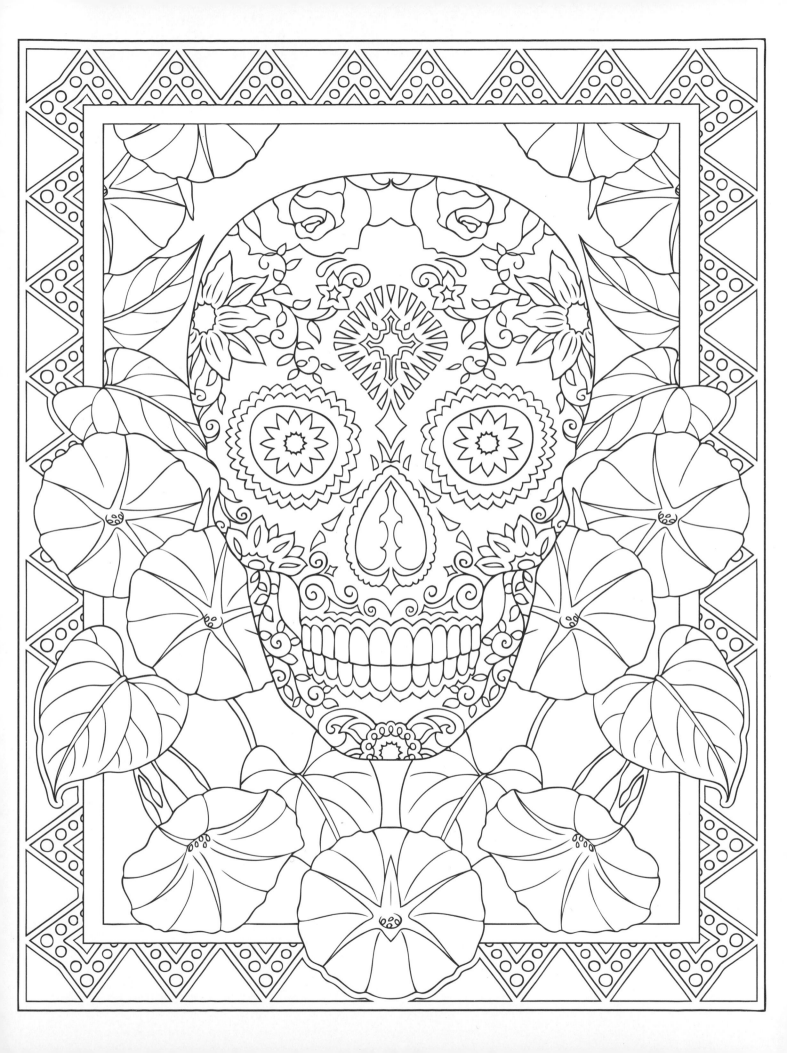

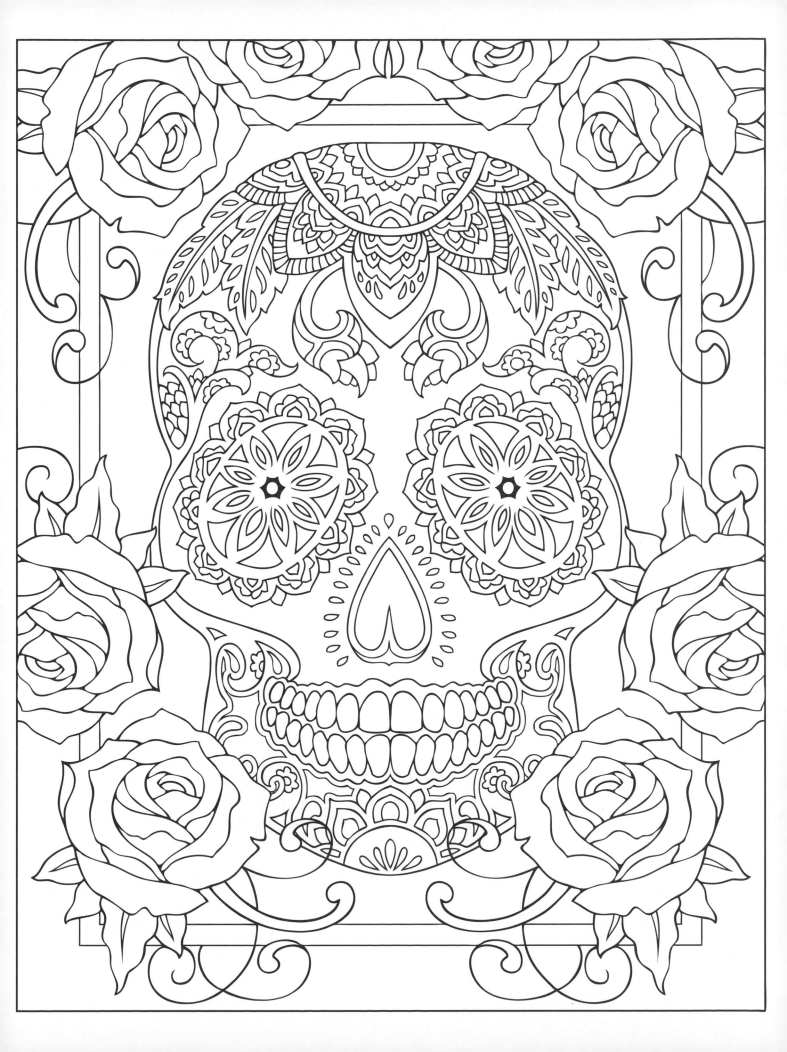

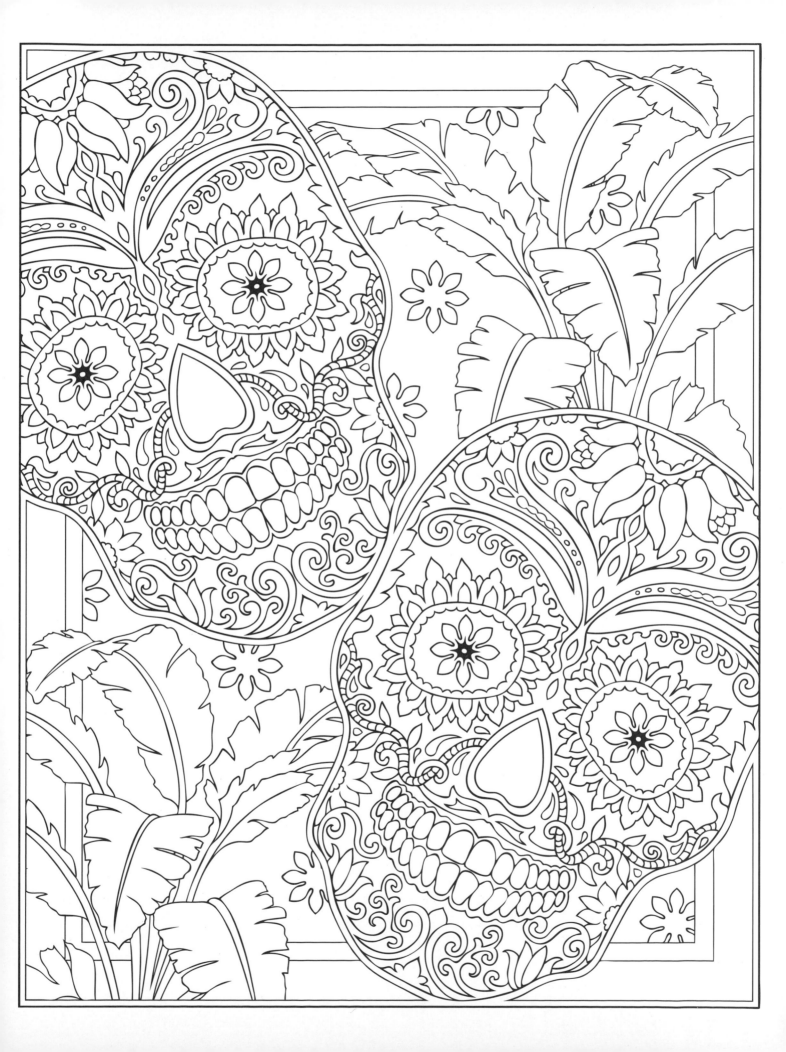

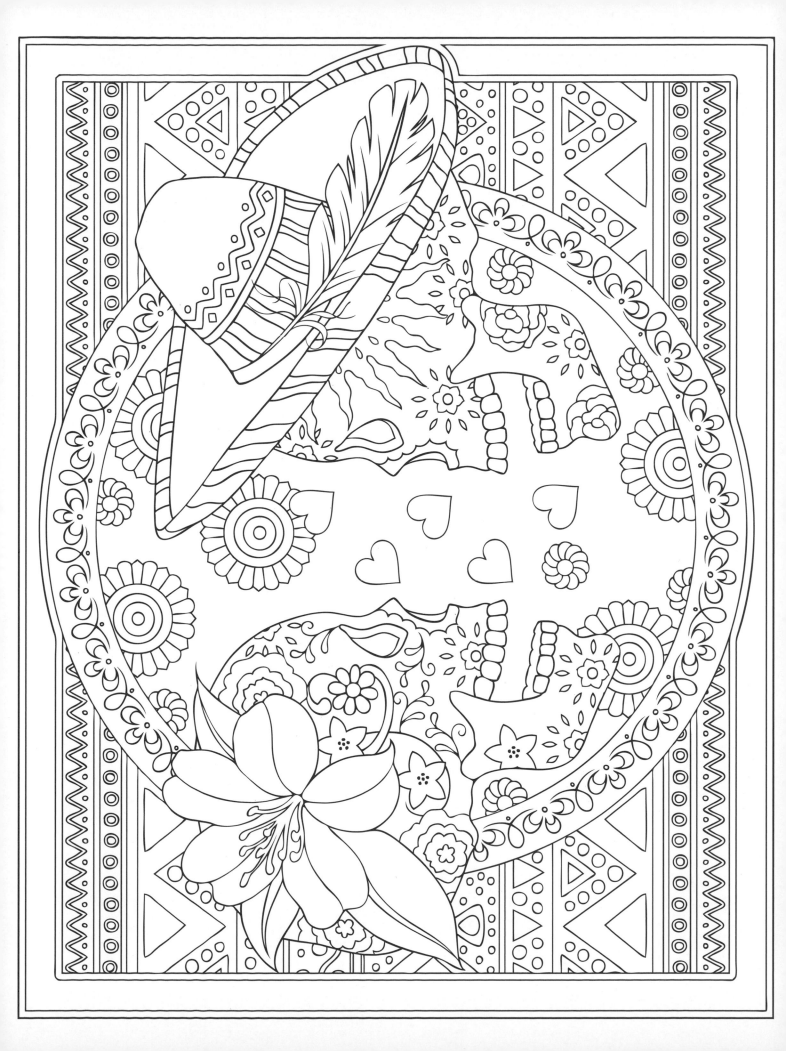

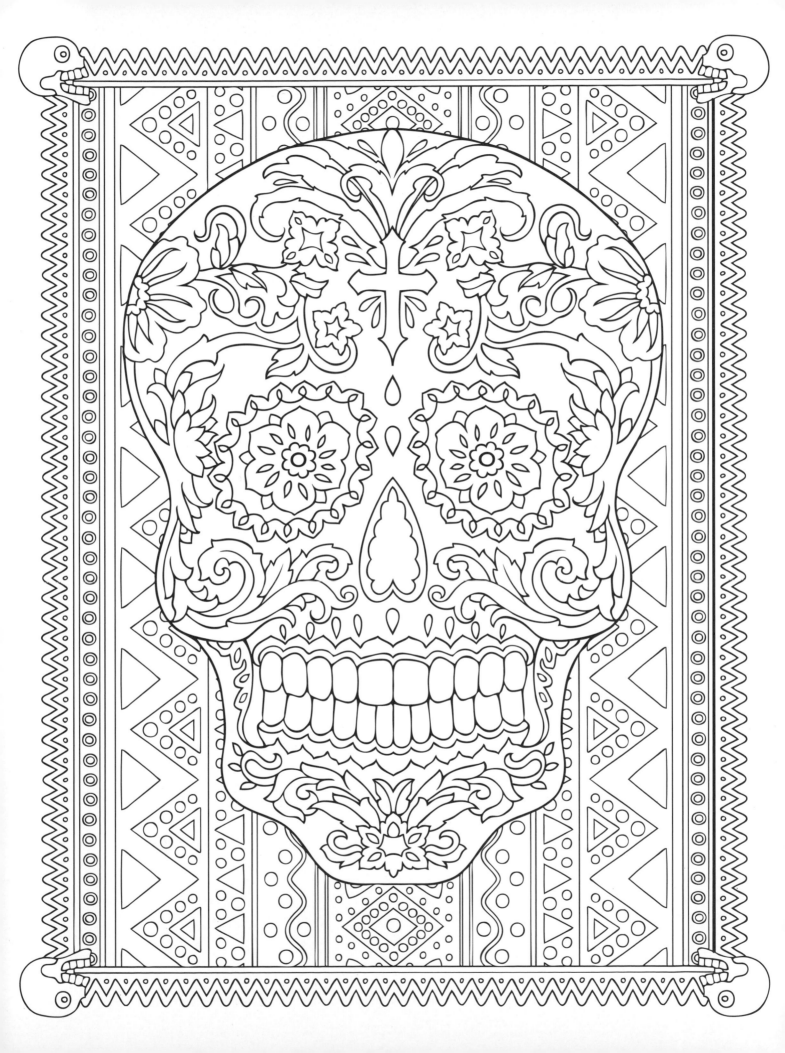

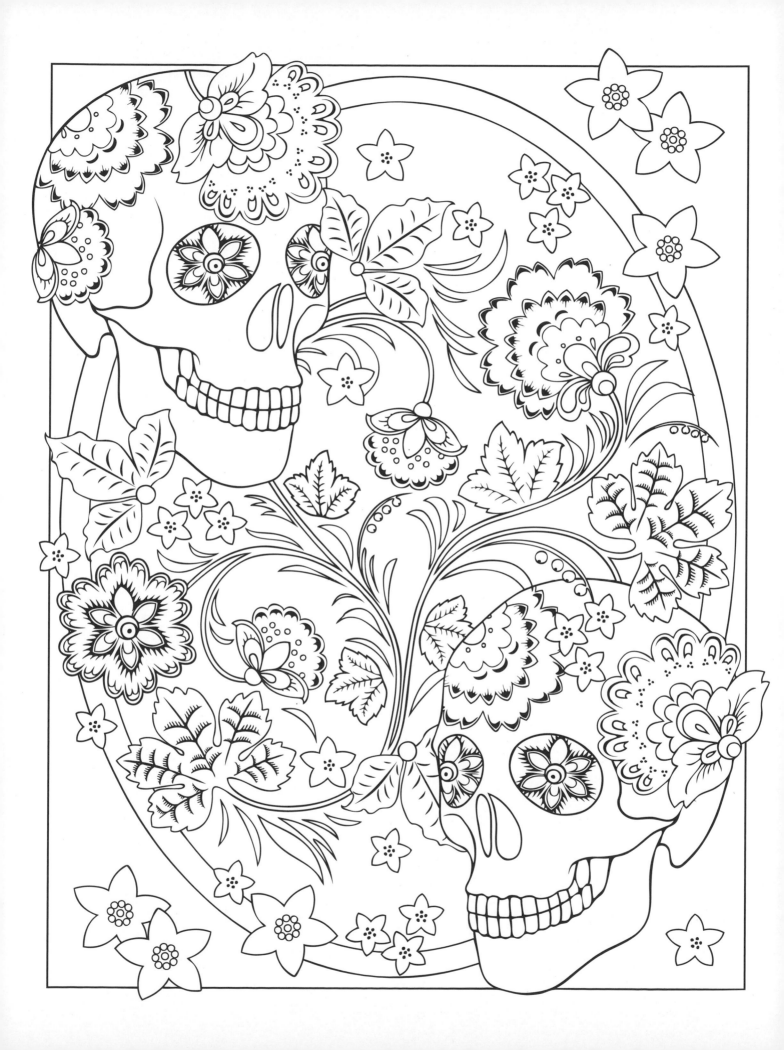

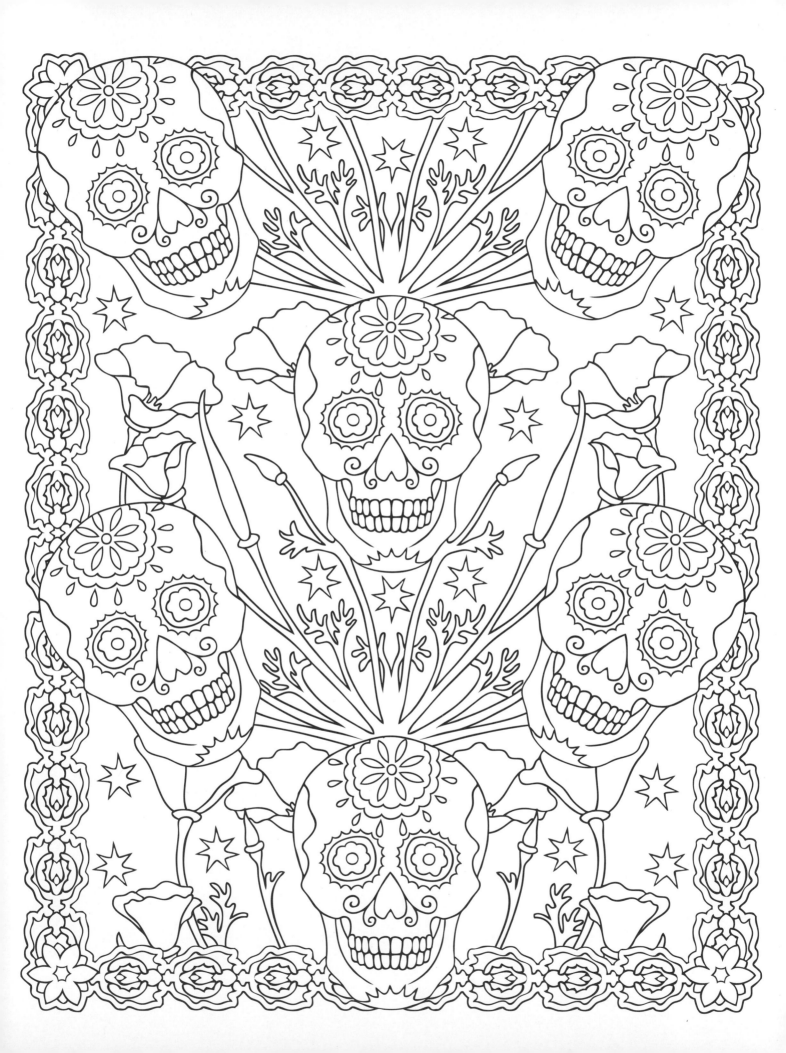

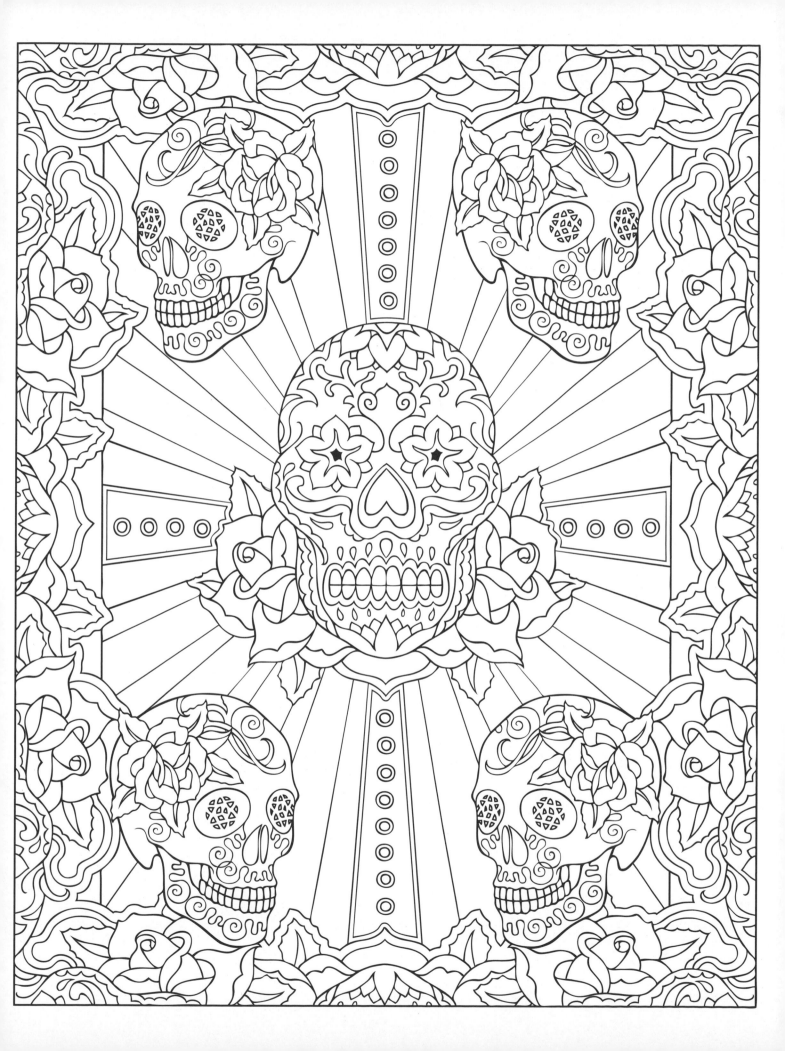

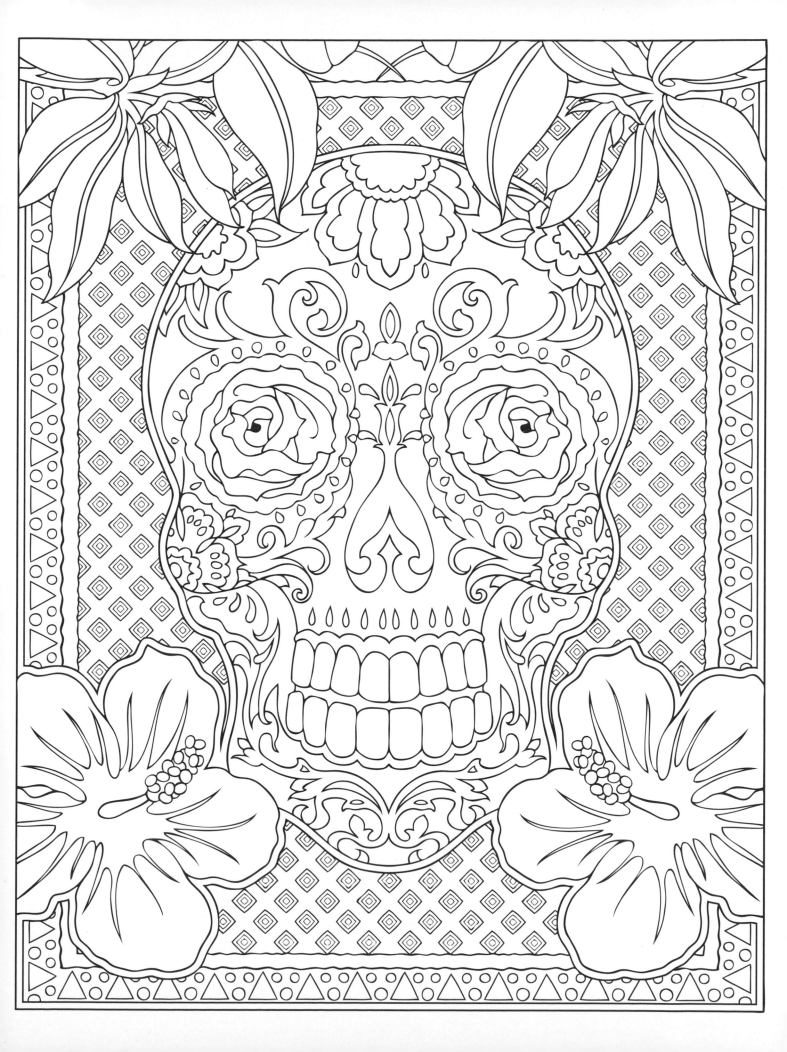

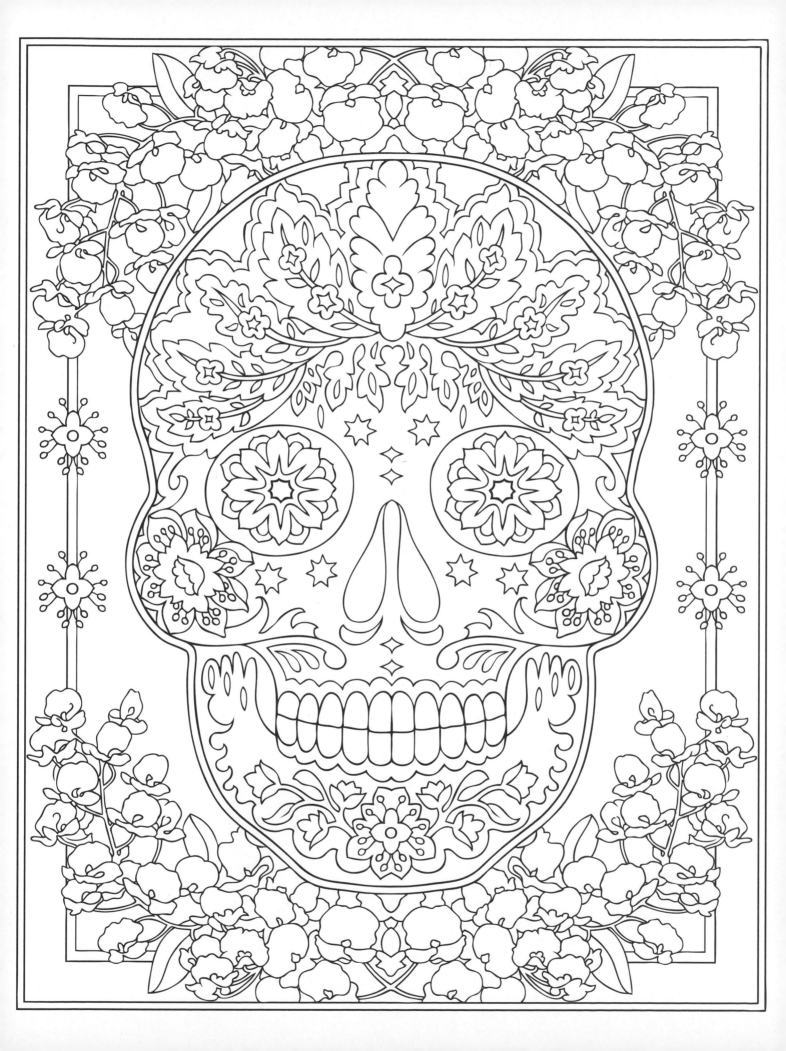

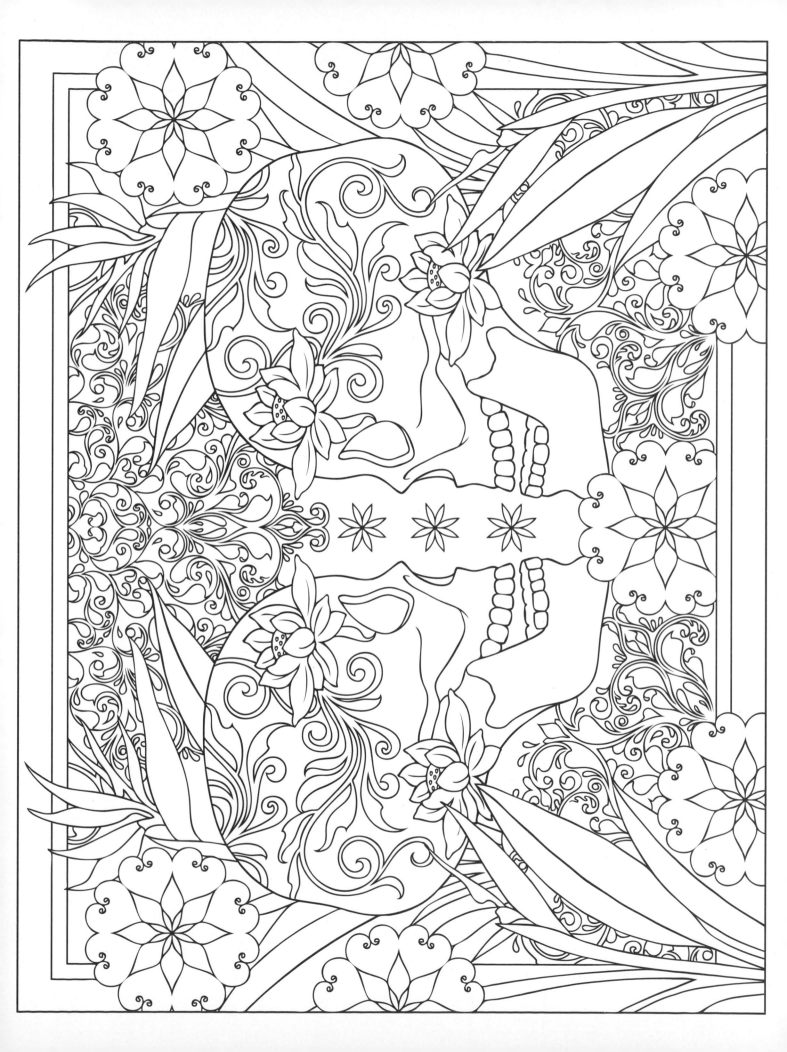

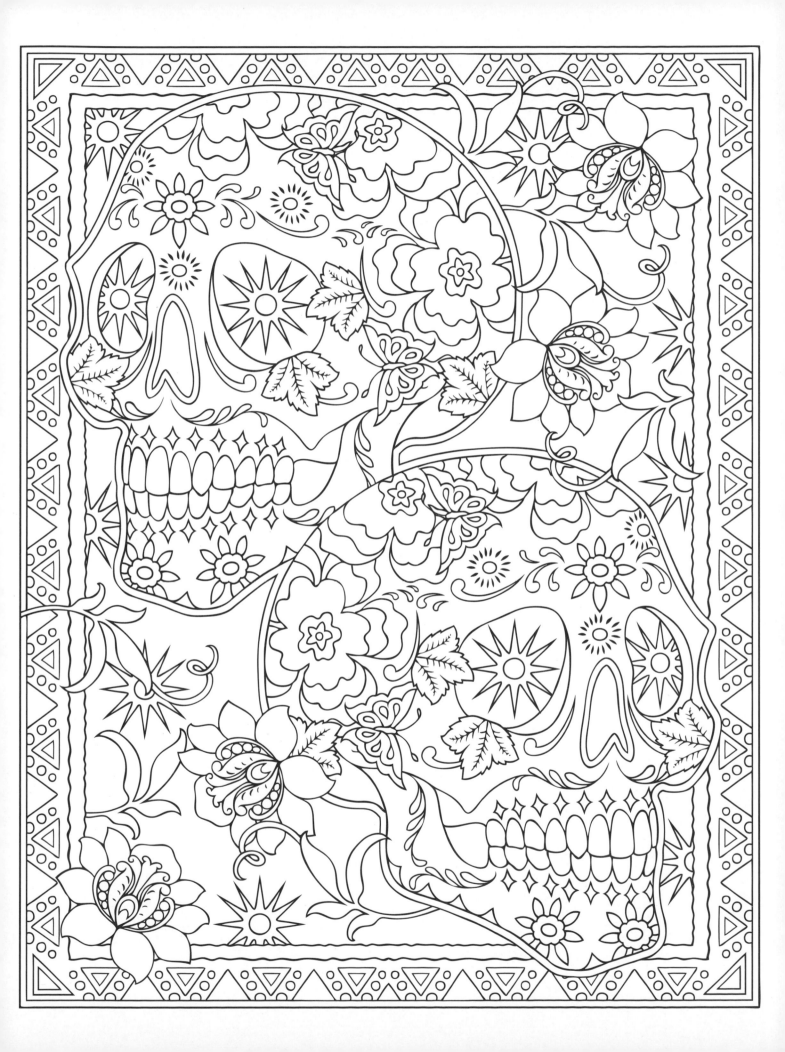

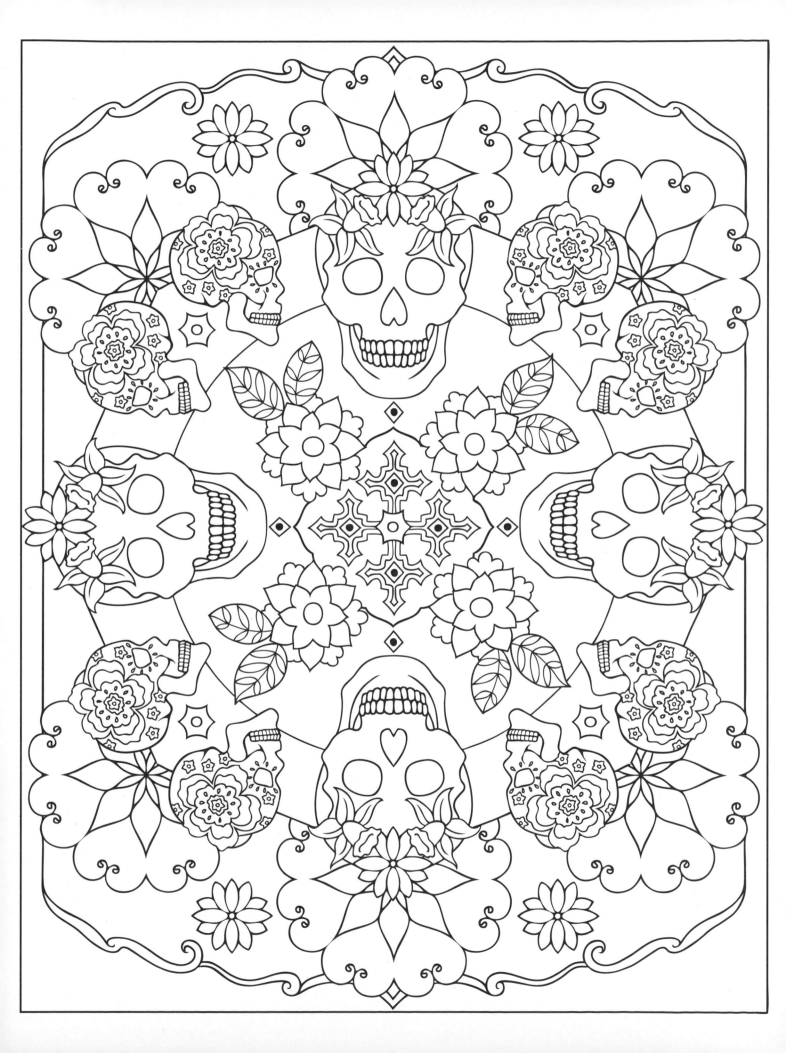

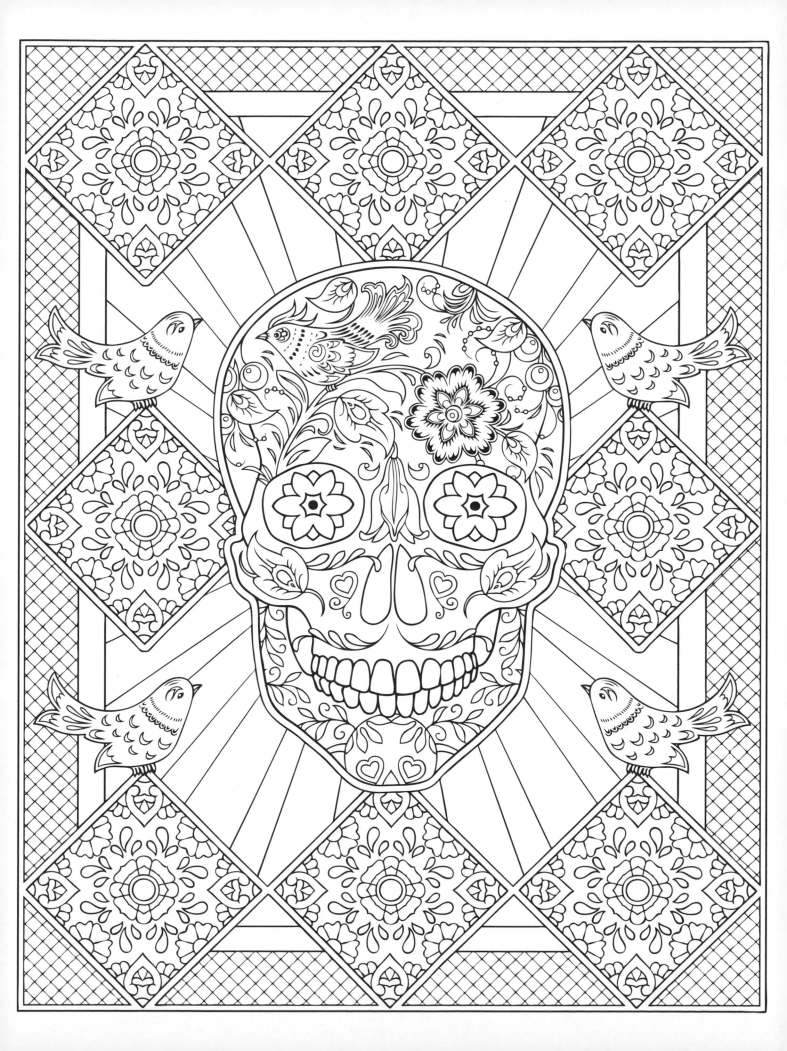

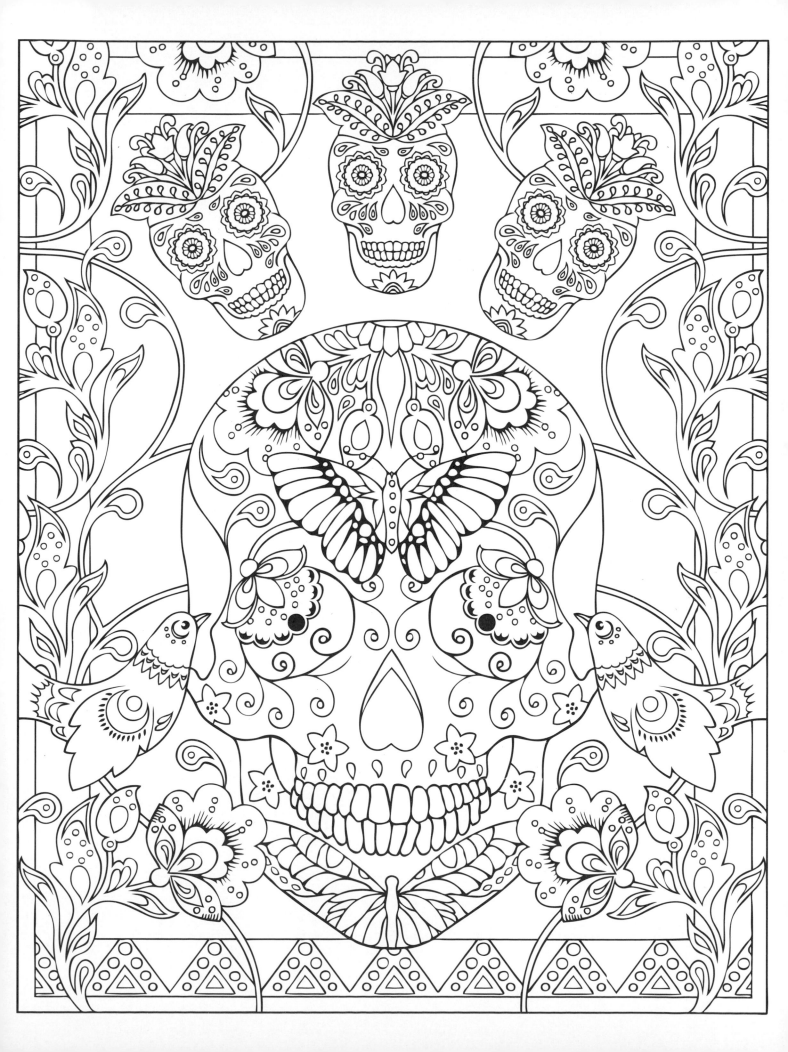

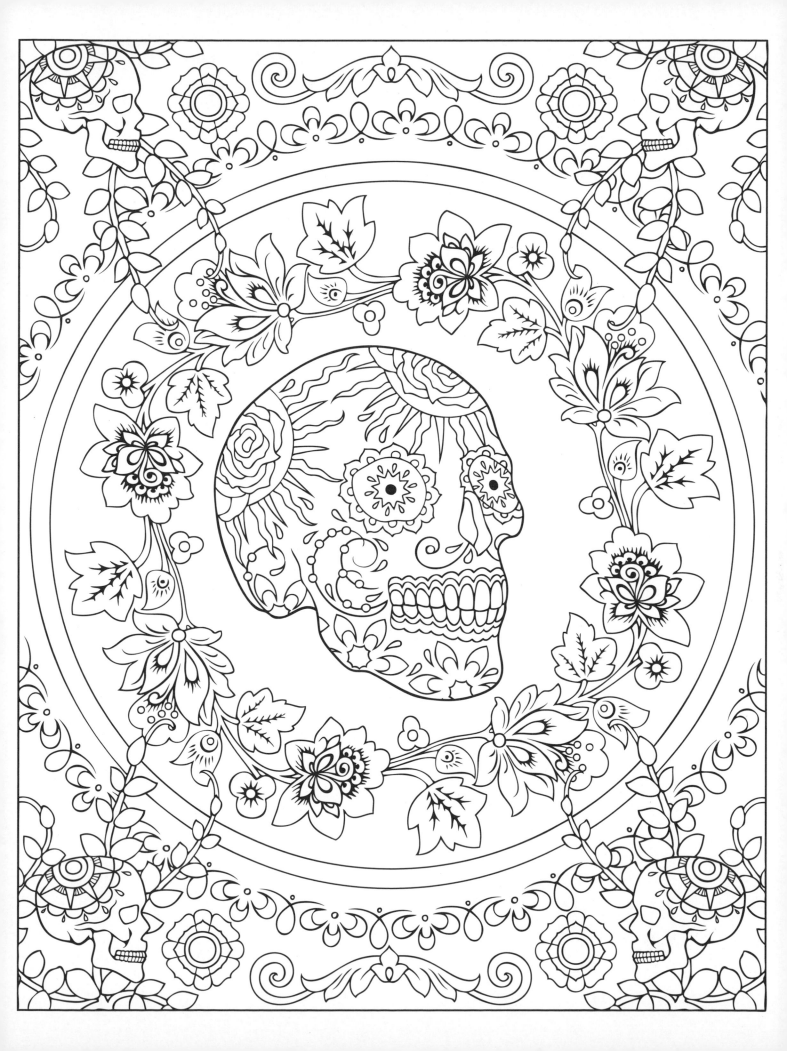

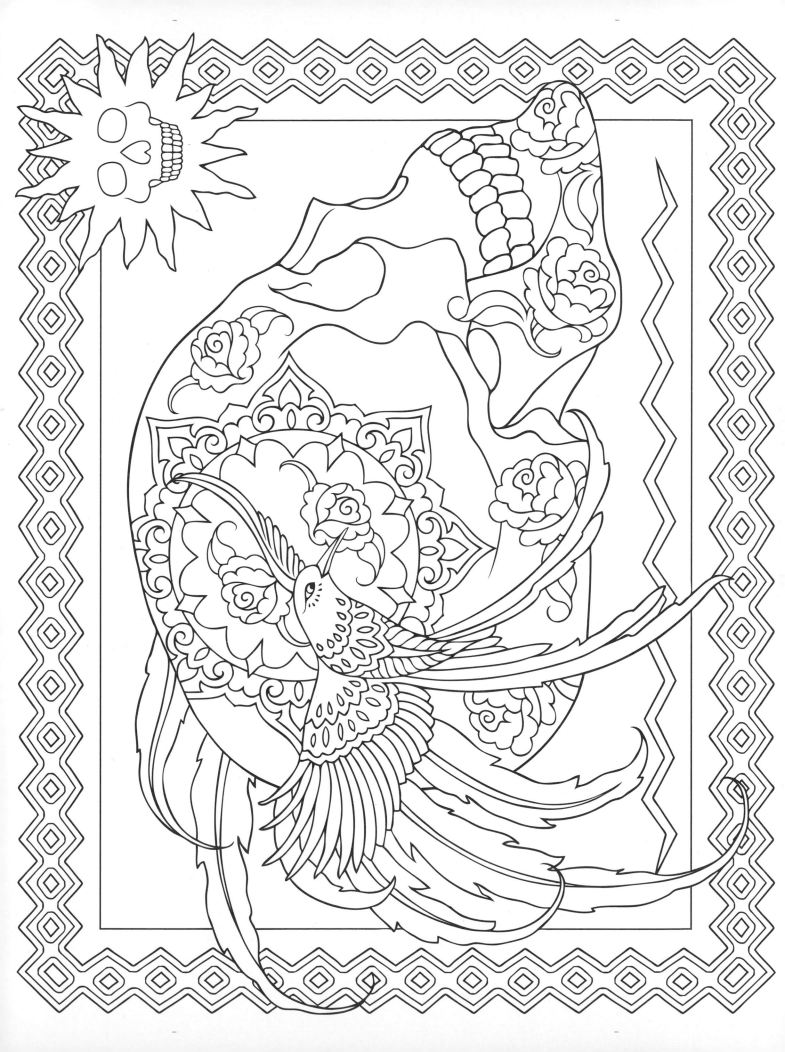

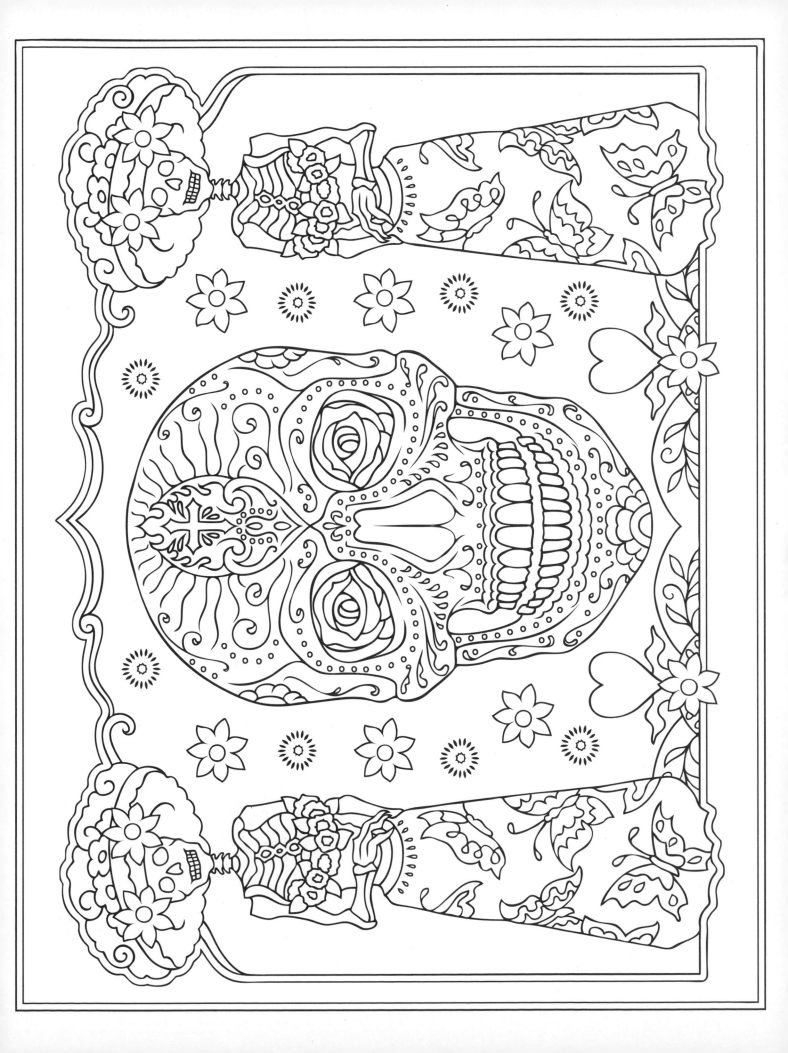

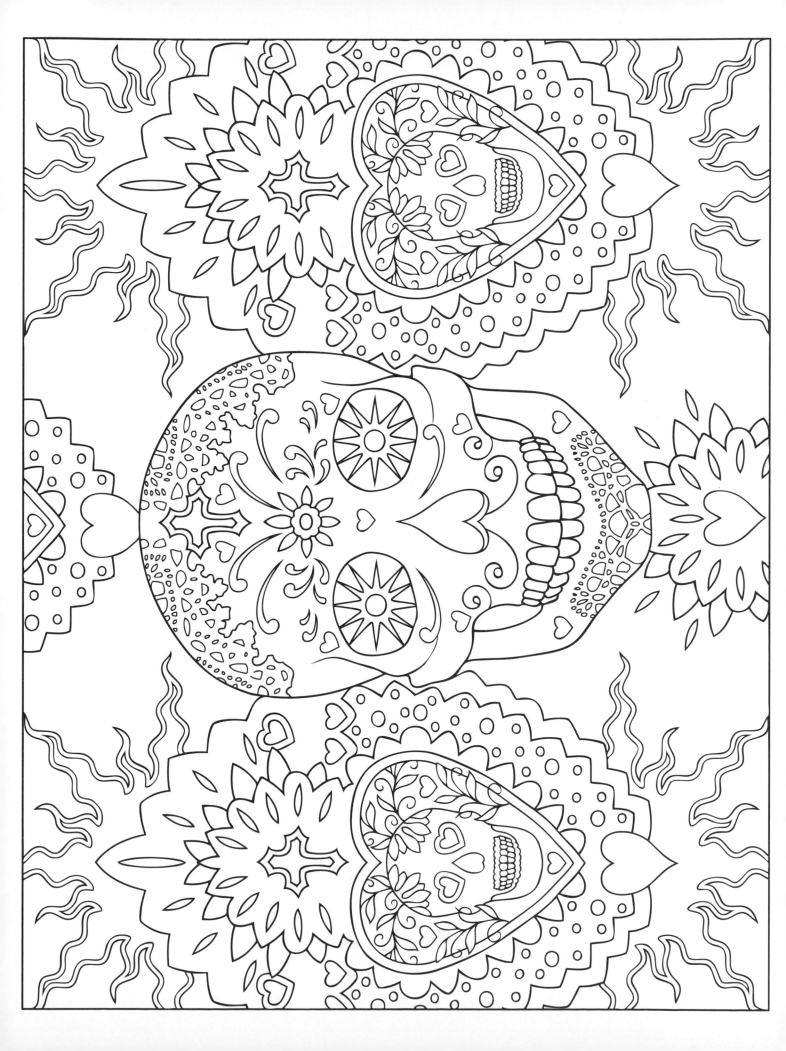

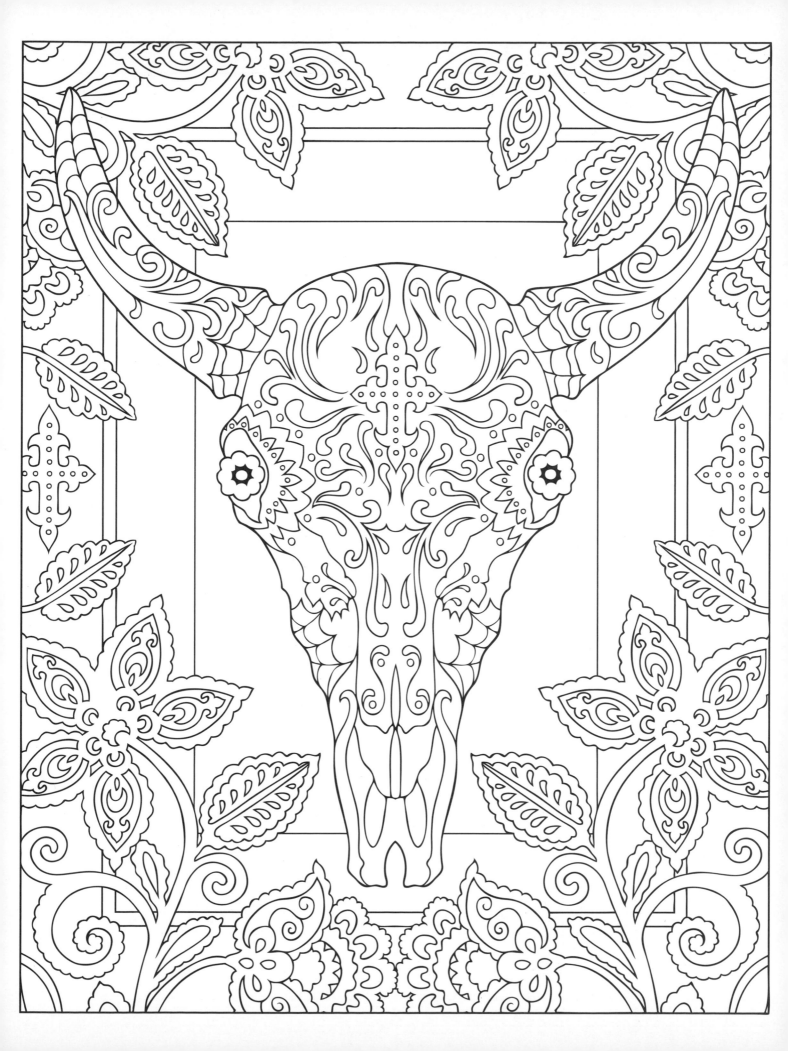

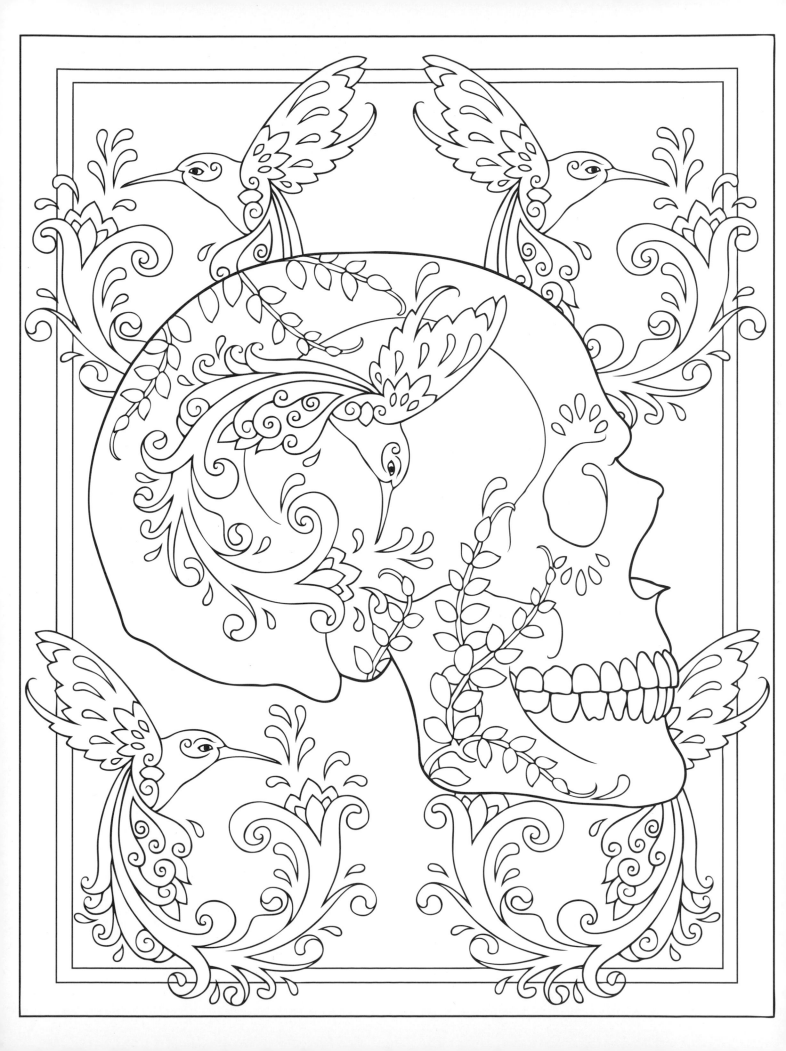

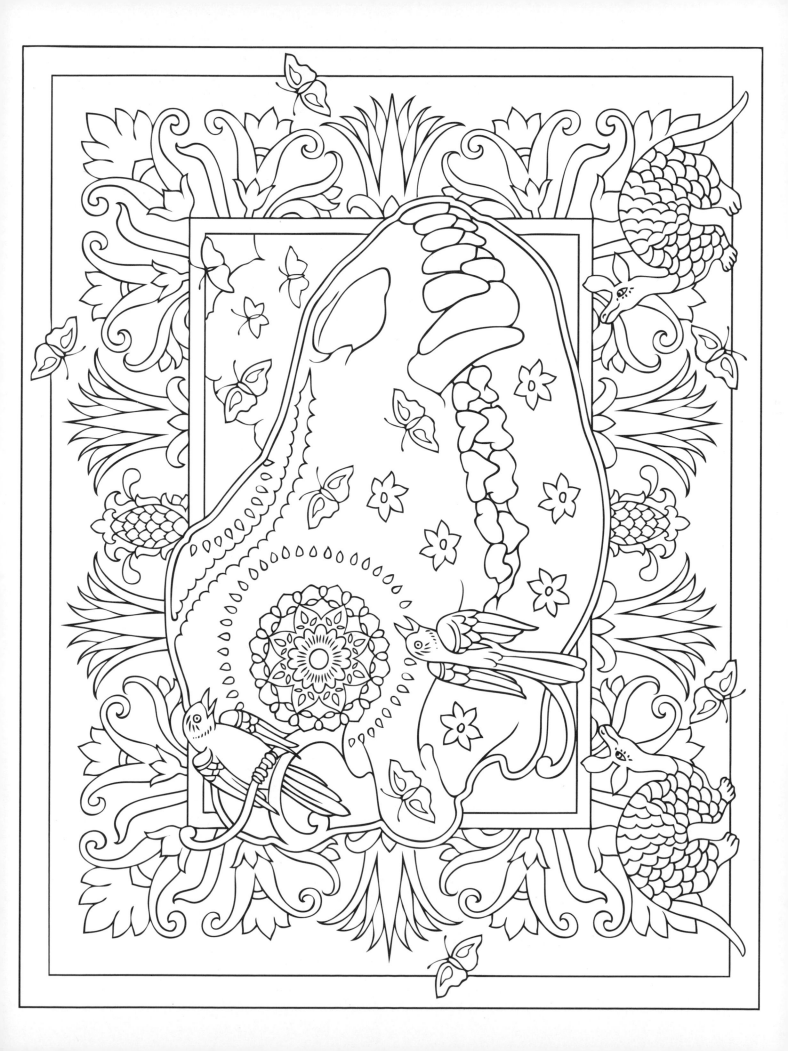

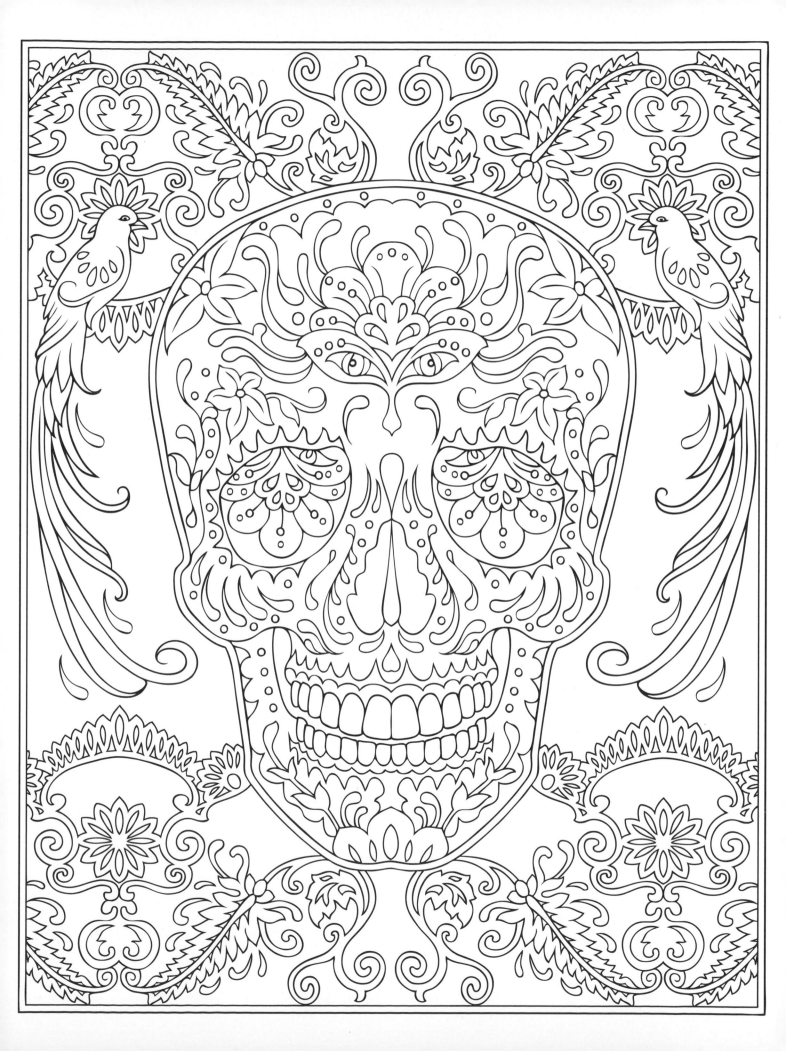

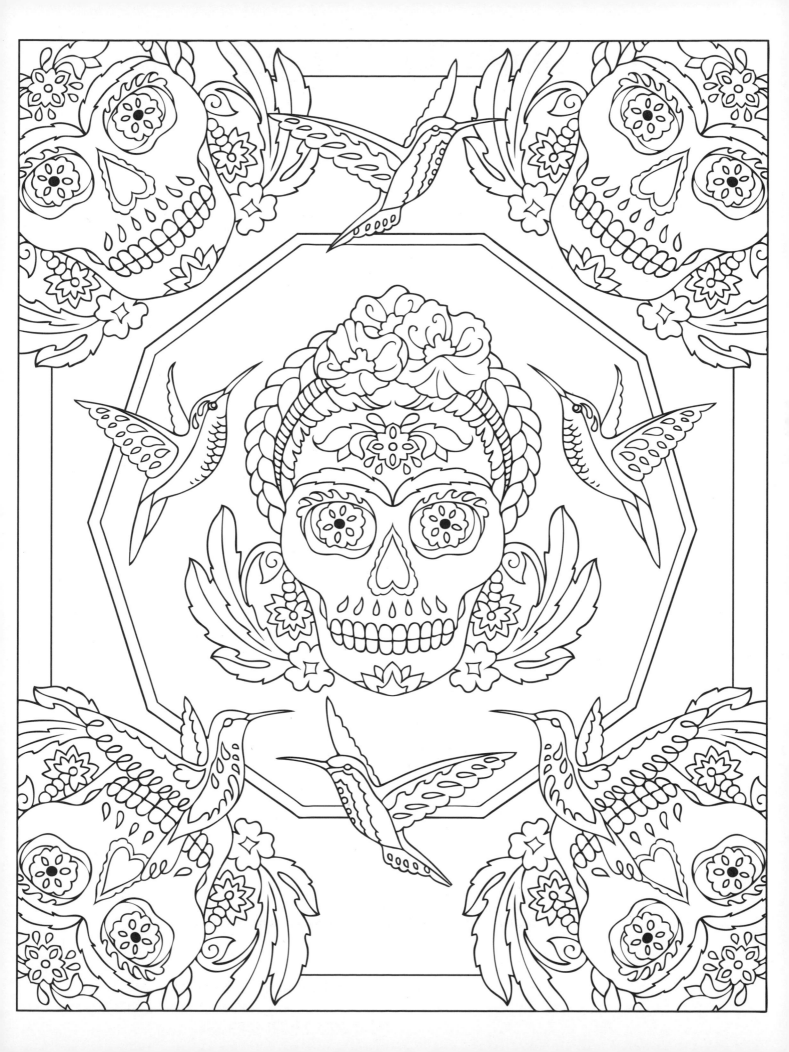

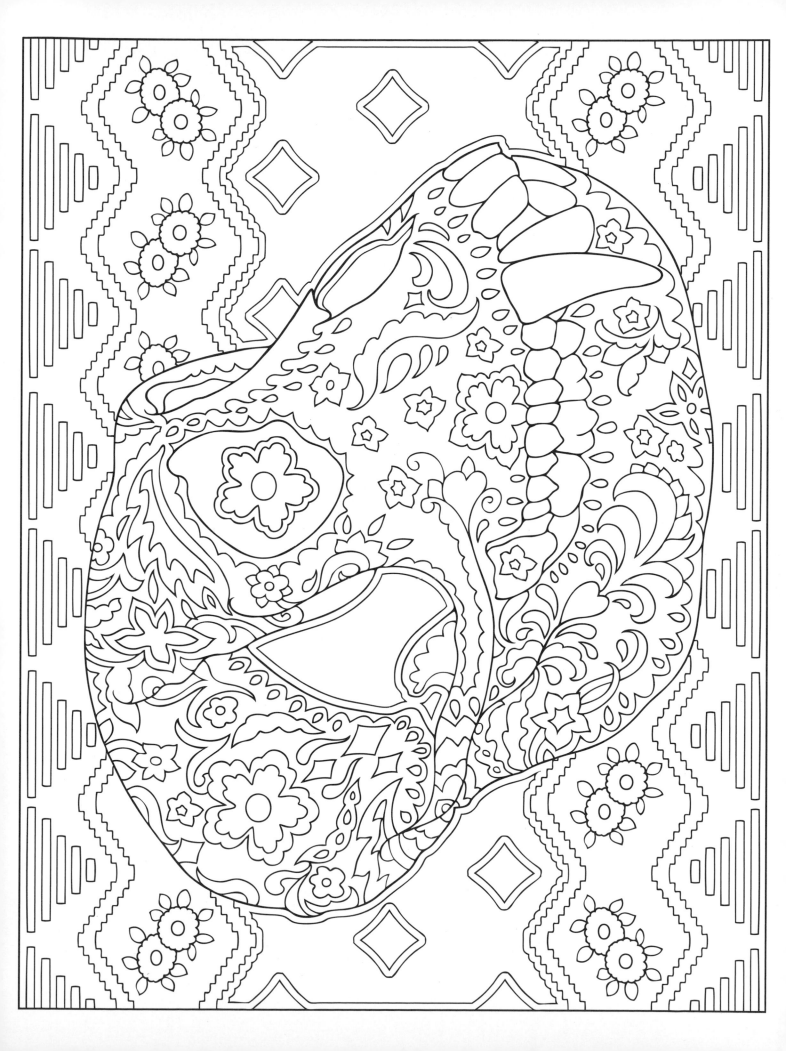

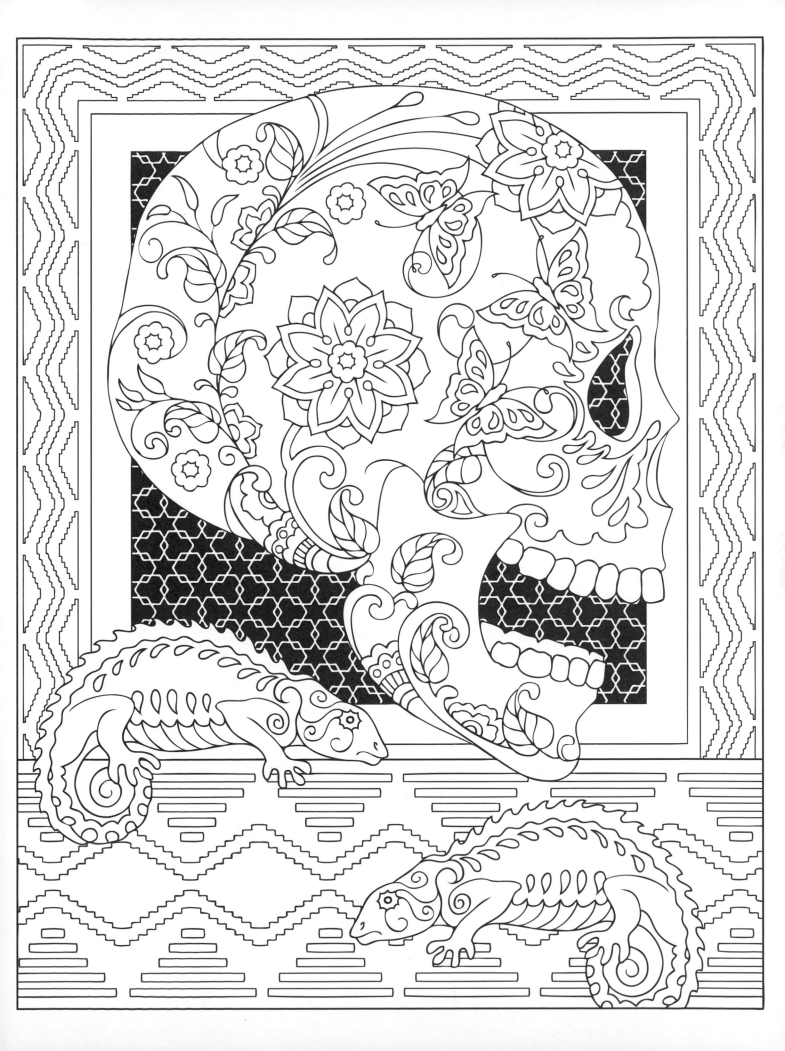

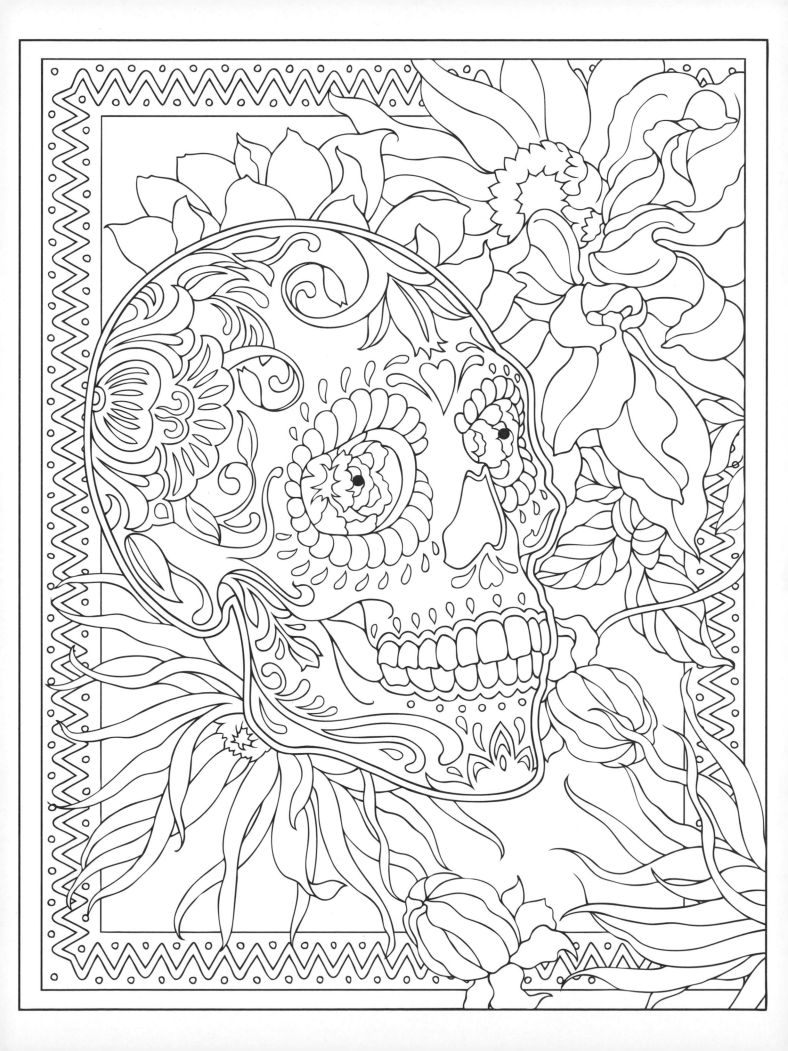

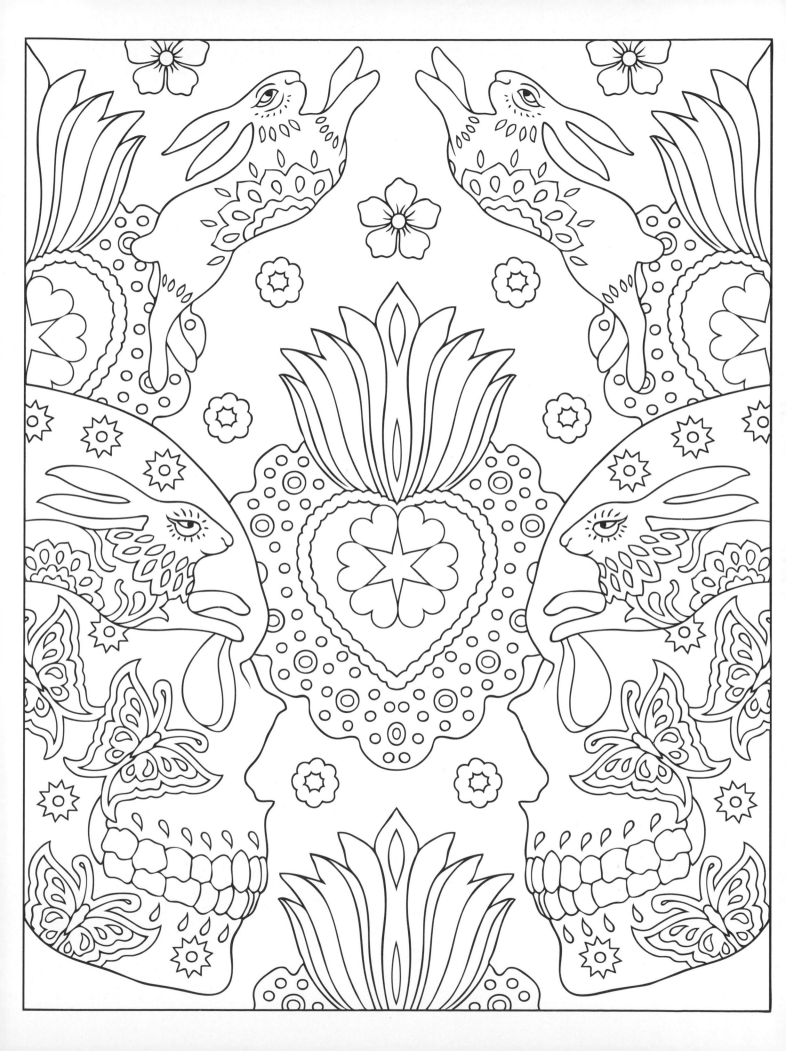

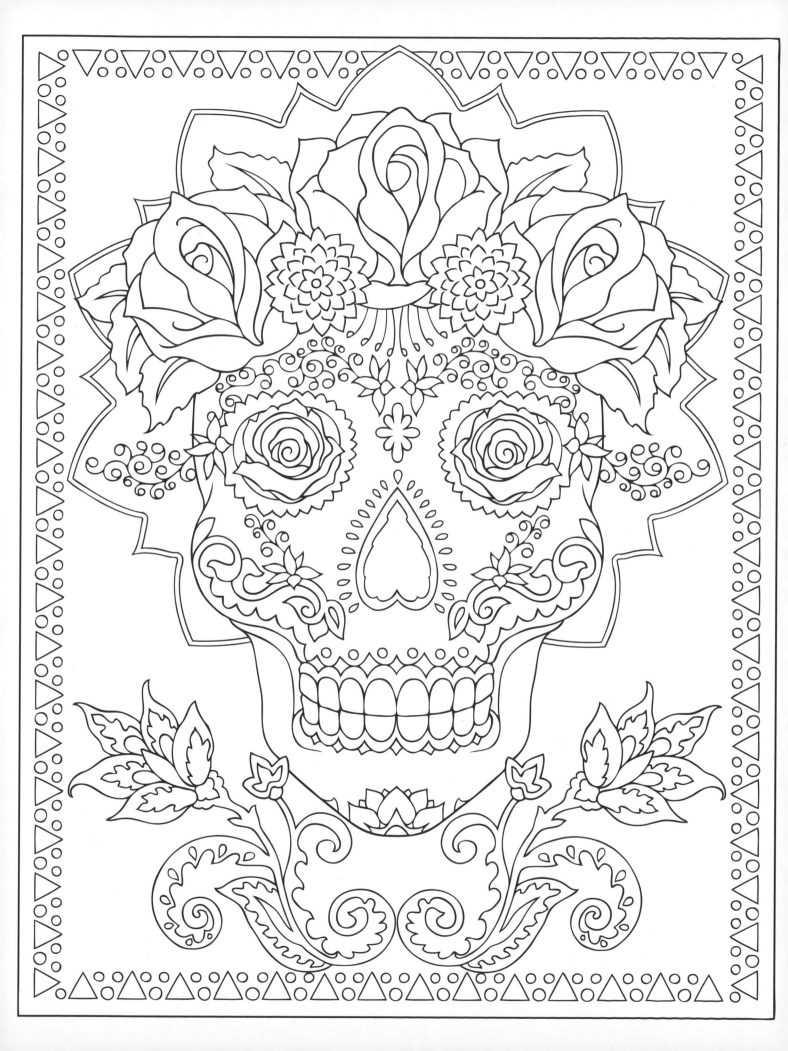

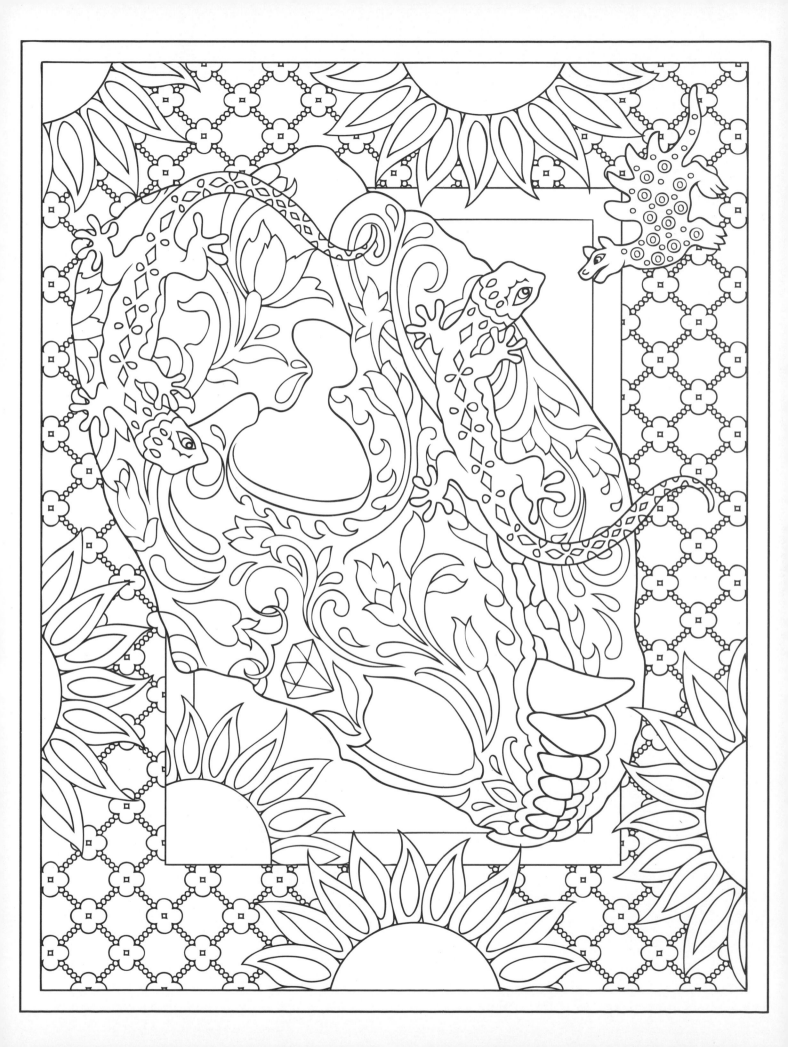

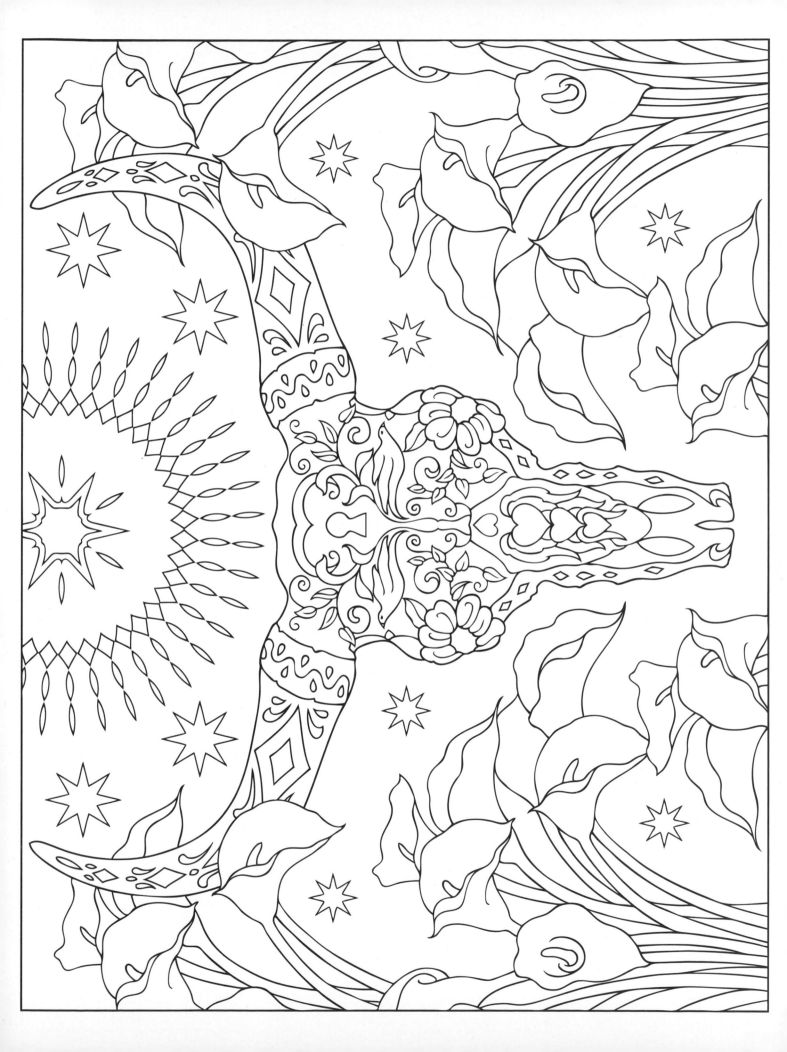

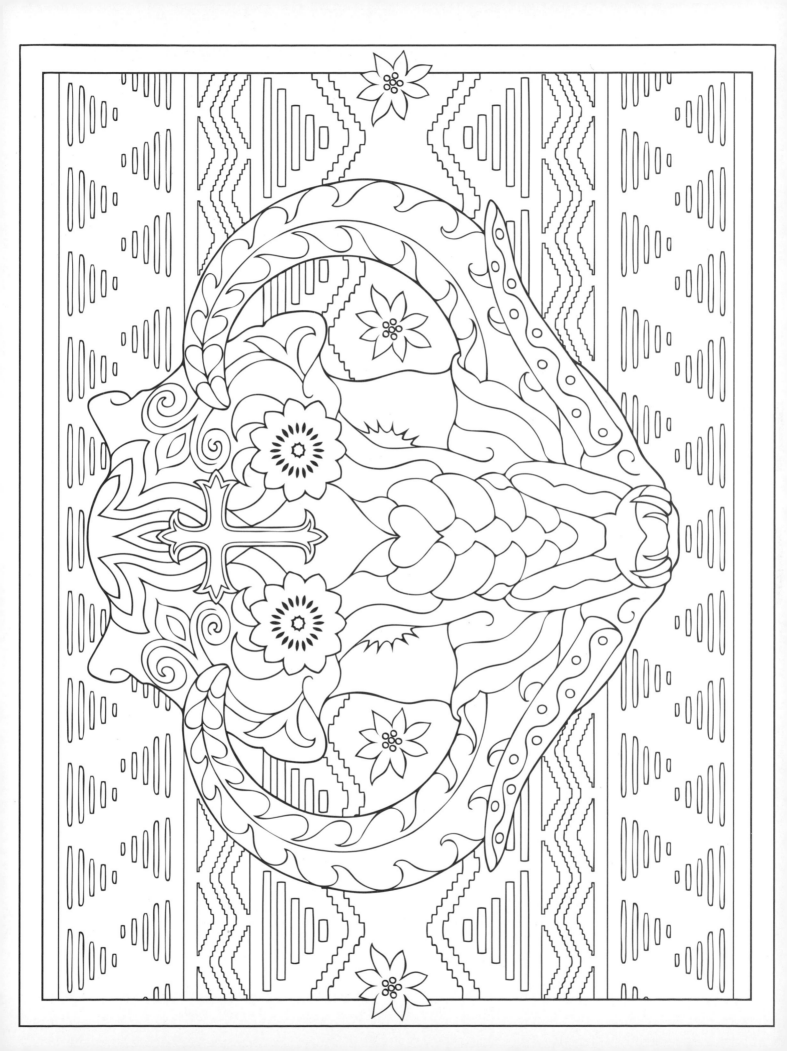

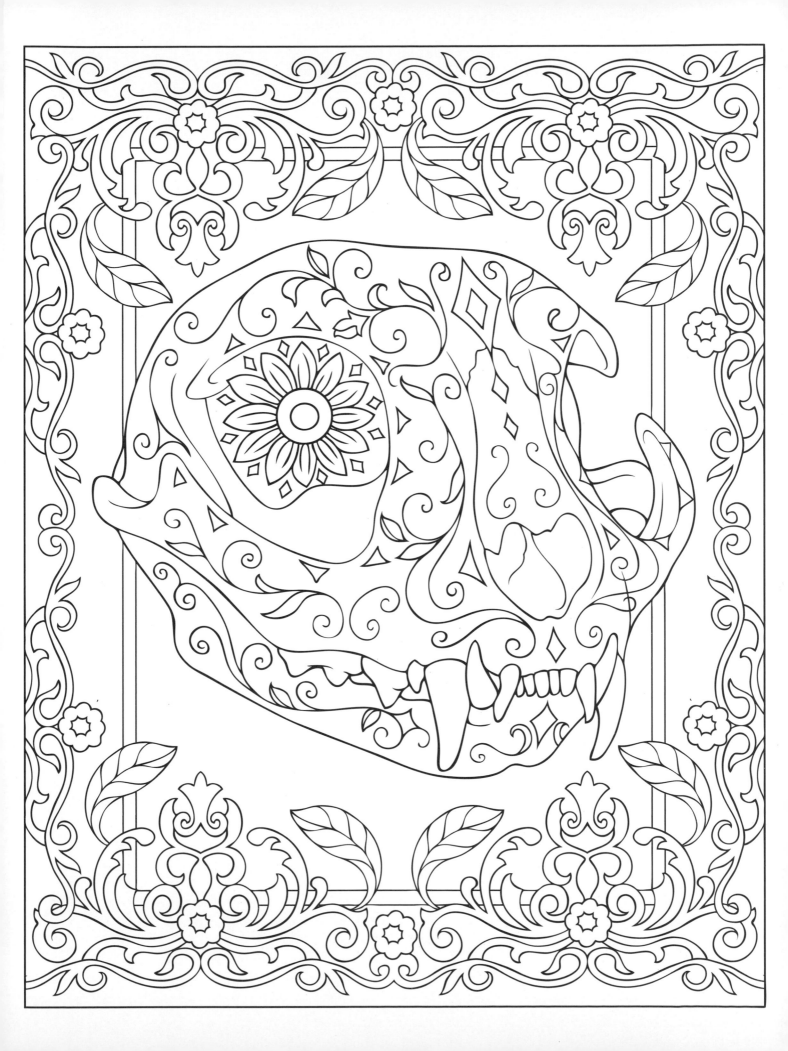

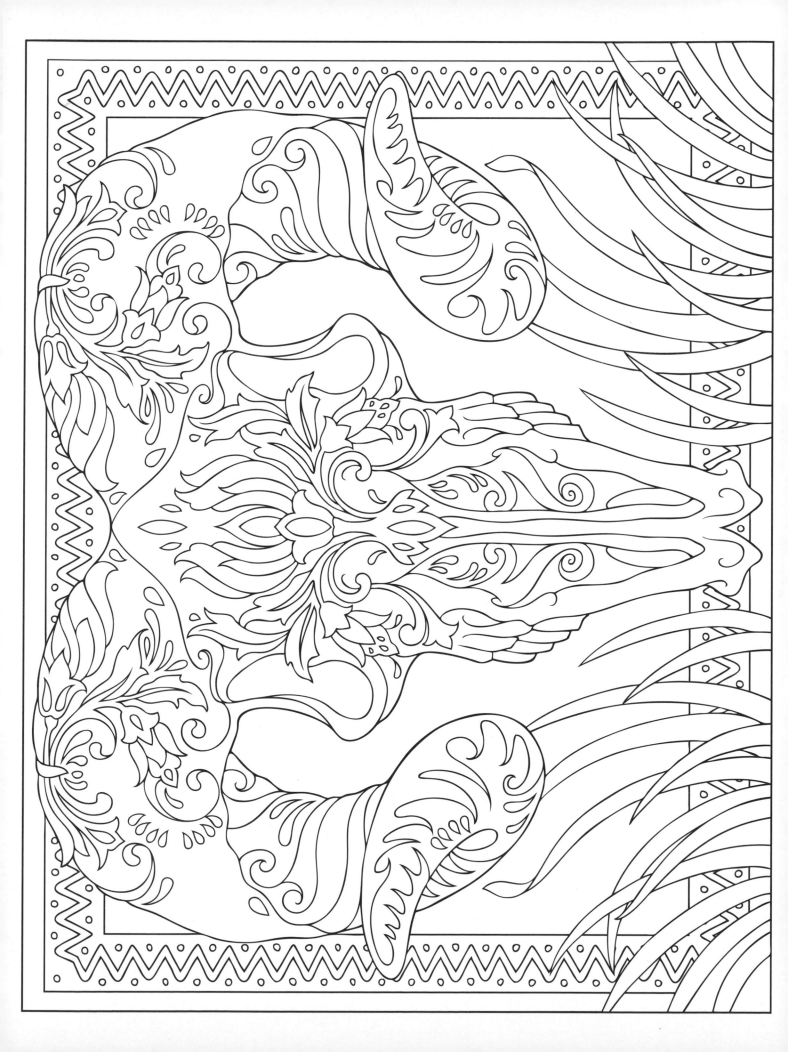

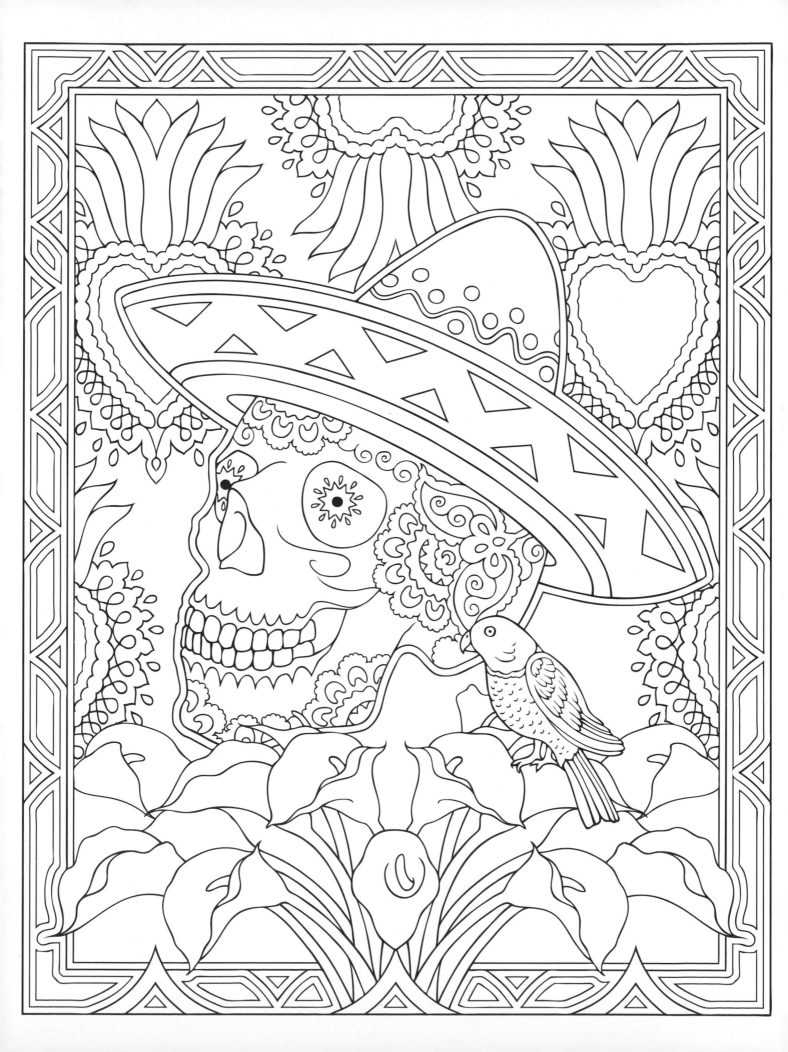

Sugar Skull Maze

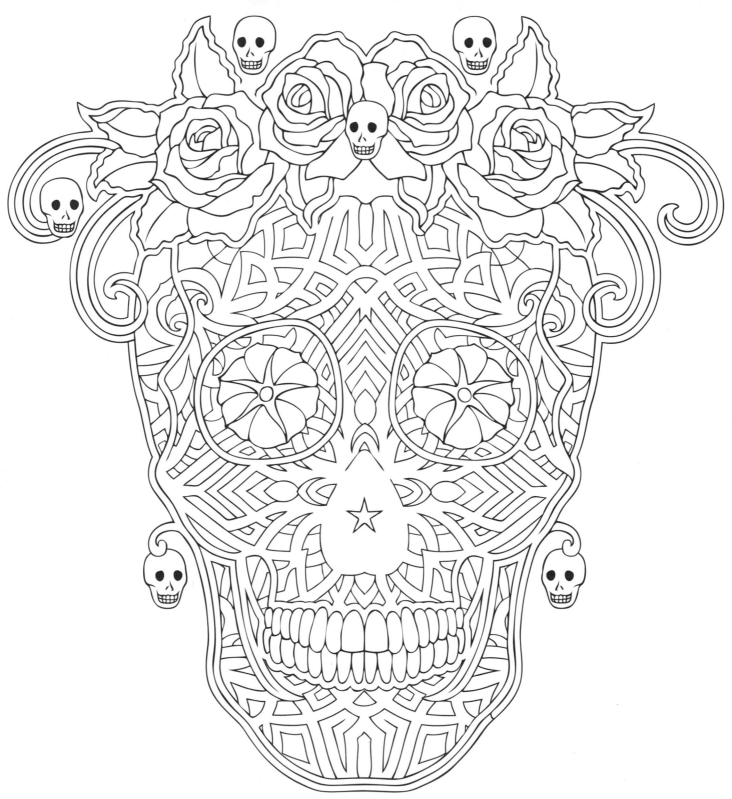

 Start at the star in the Sugar Skull nose

 End at one of the little skulls

Flip page for the answer key

Answer Key

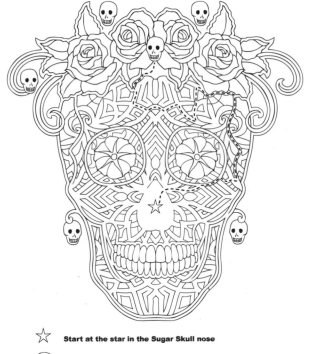

 Start at the star in the Sugar Skull nose

 End at one of the little skulls

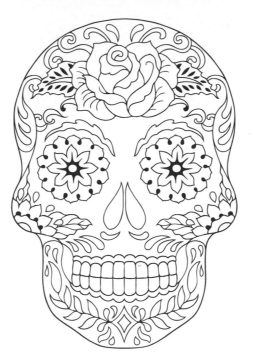

The Day of the Dead, Día de los Muertos in Spanish, is a Mexican holiday that is celebrated from November 1 through 2 to honor loved ones who have died and passed on into the spiritual afterlife. When the Catholic Spaniards first arrived in Mexico in the sixteenth century, they saw a connection between their holy day of commemorating the dead, All Soul's Day, and the indigenous Aztec celebrations of the goddess of the underworld, Mictecacihuatl. The traditions of both rituals were then combined to form the festival as we know it today. To celebrate the dead, altars called *ofrendas* are built in homes and adorned with marigolds, candles, the deceased's favorite candies, food such as *pan de muerto* (a bread roll), and beautiful sugar skulls.

The sugar skull, or *calavera*, is one of the most iconic symbols of the festival. Sugar, a local resource that is readily available to poorer populations, is molded and fashioned into the likeness of a skull and decorated with colorful icing and sparkling glitter. Sometimes, the name of the departed soul is inscribed on the forehead, and it is placed as an offering at the altar. Traditionally, sugar skulls are not meant for consumption and it can take an artist two to three days to make a single skull, and four to six months to produce skulls for an entire season! With the popularity of the Day of the Dead festival outside of Mexico, the local folk art of the sugar skull has since become a global sensation.

<div align="center">༒</div>

Marty Noble is a New York Times' bestselling coloring book artist, with more than 300 books published and over 3 million copies of her books sold. Marty was raised in Santa Barbara by a family of artists. She pursued her creative interests from an early age with the traditional Indonesian batik wax-resist dyeing technique. Her work grew from simple pieces to extremely detailed paintings that earned her a reputation in galleries, where they were sold for a period of twenty years. In the seventies, Marty switched to watercolor illustration and her art has been used in books, posters, puzzles, greeting cards, plate designs, and calendars. One of Marty's favorite subjects is illustrating the cultures of peoples from all over the world, which stems from her travels to South America, Europe, the Middle East, and Southeast Asia. Today, Marty lives in Santa Barbara, California, where she finds continual inspiration for her current series of photo art prints that depict the natural beauty of Southern California.